MW00343438

A Culinary History of

IOWA

A Culinary History of
IOWA

SWEET CORN, PORK TENDERLOINS, MAID-RITES & MORE

· DARCY DOUGHERTY MAULSBY·

AMERICAN PALATE

Published by American Palate
A Division of The History Press
Charleston, SC
www.historypress.net

Copyright © 2016 by Darcy Dougherty Maulsby
All rights reserved

Cover images: The corn grows tall near a farmstead in northwest Iowa. *Author's collection*; an array of pies, from strawberry-rhubarb to cherry to peach, tempt bicyclists who stop at food stands in small towns and cities across Iowa as they pedal across the state each July for RAGBRAI (Register's Annual Great Bicycle Ride Across Iowa). *Author's collection.*

First published 2016

ISBN 9781531698768

Library of Congress Control Number: 2016936009

Notice: The information in this book is true and complete to the best of our knowledge. It is offered without guarantee on the part of the author or The History Press. The author and The History Press disclaim all liability in connection with the use of this book.

CONTENTS

ACKNOWLEDGEMENTS

When you undertake a project as massive as trying to tell even a slice of Iowa's rich culinary history, you certainly can't do it alone.

I appreciate all the help I've received from many resources, including various restaurants, museums, libraries, amateur historians and foodies across the state. I'd especially like to thank Iowa's amazing independent restaurants like Cronk's in Denison, the Northwestern Steakhouse in Mason City, Archie's Waeside in LeMars, Breitbach's Country Dining in Balltown and so many others that make Iowa a much more interesting, flavorful place to live and visit.

It's exciting to see how Iowa's talented chefs are transforming Iowa's dynamic culinary scene. I'm forever grateful to my friend Chef George Formaro of Des Moines for patiently answering my questions related to food, recipes and more. It's wonderful to find a kindred spirit when it comes to preserving Iowa's culinary history.

Thanks, also, to the fine staff at the Hotel Julien Dubuque, not only for welcoming me to experience this legendary hotel but also for showcasing a unique piece of local history. I also appreciate all the friendly, helpful people who have shared stories of great Iowa food businesses, from the Mississippi River to the Missouri River.

In addition, I'm glad to see so many history buffs and foodies sharing photos, stories, memorabilia and more on fun social media sites like "Iowa on a Plate" on Facebook, as well as "Lost Des Moines," "Memories of a Younkers Tea Room," the "Forgotten Iowa Historical Society" and

more. It's great to live in a time when history can live on and reach a wider audience than ever.

I know I haven't properly thanked everyone who contributed to this book, but rest assured, I do appreciate all the food for thought you've given me that I can share with readers. Finally, I'd like to thank my commissioning editor, Ben Gibson, and the great team at The History Press for making this book possible and helping preserve Iowa's culinary history. Let's dig in!

INTRODUCTION

In Iowa, "We don't meet if we don't eat" could be the state's unofficial motto. It makes sense, if you think about it. When you're blessed to live in one of the world's most abundant agricultural regions, you live close to the land and benefit from the bounty it provides, including fresh, delicious food.

While Iowa isn't always recognized as a culinary epicenter, I've always believed that no one knows more about the fine points of food than those who produce it. Is it any wonder that generations of Iowa farm cooks mastered the art of preparing exceptional meals made with farm-fresh ingredients? It's also clear that Iowa's food scene has been evolving in recent years. New generations of innovative Iowa chefs and home cooks are adding their own twists on Iowa fare as they create memorable meals with some of the best beef, pork, turkey, sweet corn and home-grown produce raised in America.

A unique mix of progressivism and provincialism is reflected in Iowa's food, as well as its culture and politics. This is a state distinguished by some beloved culinary traditions that offer an extraordinary taste of Midwestern life, from Maid-Rite loose-meat sandwiches to dinner plate–sized breaded pork tenderloins to the classic school lunch combo of chili and cinnamon rolls. And don't forget Jell-O, which often shows up in dishes that most people would consider desserts but Iowans define as "salads."

As I've explored my home state's culinary traditions, I've been impressed by just how passionate Iowans (and former Iowans) are about Iowa food. It's also inspiring to see just how much care, love and energy Iowans infuse into everything they do, whether they farm, run a mom and pop restaurant or

prepare favorite recipes for family and friends. Through it all, I'm reminded of the importance of supporting locally owned businesses and giving back to the local community when I visit with Iowans who remain rooted in the essentials of farming, faith and food.

As I've compiled a smorgasbord of stories, recipes and photos for this book, I know I've only scratched the surface. While this is just a tantalizing slice of Iowa's culinary history, I hope it offers you a new taste of what makes Iowa distinctive and remarkable. Come along on this delectable journey and feast on Iowa's extraordinary culinary history.

Chapter 1

EXPLORING IOWA

L ocated in the heart of America, Iowa is "the land between two rivers," a region of the Midwest distinguished by a surprisingly rich, diverse cultural and culinary history.

Between the forests of the eastern United States and grasslands of the Great Plains to the west, Iowa's gently rolling landscape extends westward from the Mississippi River, which forms the state's entire eastern border. The Missouri River forms the western border, making Iowa the only U.S. state with two parallel rivers defining its borders.

Rivers were the early highways, bringing explorers, trappers, traders and settlers to the Iowa prairie. Centuries before the Europeans arrived, however, various Native American tribes—including the Sac, Fox, Sioux, Ioway, Meskwaki and others—lived, hunted and farmed across the region. The meaning of the name *Iowa* depends on who you ask. Traditionally, it has been described as an Ioway word meaning "the beautiful land," although others say that *Ioway* itself is the French spelling of *Ayuhwa*, a name meaning "sleepy ones," a name given in jest to the Ioway tribe by the Dakota Sioux.

Living off the land defined the food and farming traditions of tribes like the Ioway, whose history is carefully re-created at Living History Farms in Urbandale. Ioway farmers raised corn, beans, melons and squash. Women did the farming in the Ioway culture, while men were responsible for hunting and making tools. Ioway families were subsistence farmers, raising just enough for their family to survive throughout the year and having a little put away in case of a bad year.

The Ioway had separate summer, winter and traveling lodges. Bark houses called *náhachi* kept the Ioway cool during hot summer months, while winter mat-houses called *chákirutha*, made from layers of sewn cattail leaves, protected the Ioway from harsh winters and stayed around fifty degrees inside. While traveling on hunting expeditions, the Ioway lived in a *chibóthraje*, or tipi made from buffalo hides. Their villages also contained sweat lodges, food-drying racks, cooking areas, work areas, hide-scraping racks, pottery pits and gardens.

At Living History Farms, historical interpreters at the 1700 Ioway Farm discuss hunting, hide processing, fur trading, tool making, gardening, food processing and the roles that Ioway men and women played in each. Interpreters use both re-created bone and stone tools and reproduced trade items to perform daily tasks.

By the era of the 1700 Ioway Farm depicted at Living History Farms, the first Europeans had seen the land that would become Iowa. Had history taken a different course centuries ago, Iowans might be known for their unique brand of French cuisine with a distinctly Midwestern flair.

In the late 1600s, European explorers began paddling up and down the Mississippi River, passing along Iowa's eastern border. The first to visit Iowa were Frenchmen. Louis Joliet led a crew accompanied by Father Marquette, a Catholic priest. In 1673, the expedition arrived in the area that includes Pikes Peak State Park near the Iowa town of McGregor. It would be almost 150 years after Marquette and Joliet sailed along Iowa's eastern border before white settlers began moving inland to farm Iowa's incredibly rich topsoil.

In the meantime, trappers and traders began exploring the rivers that fed into the mighty Mississippi. The French established some trading posts that would grow into Midwestern cities, including St. Paul., Minnesota; Prairie du Chien, Wisconsin; and St. Louis, Missouri.

In the 1780s, a young Frenchman named Julien Dubuque learned that there were rich deposits of lead ore on the west side of the Mississippi River near Prairie du Chien. Lead was valuable because it was used to make ammunition for guns and cannons. Dubuque lived among the Native Americans in the area and mined the ore. Dubuque set up lead mines near the location of the city that bears his name and lived in the area until he died in 1810.

Lewis and Clark and the
Corps of Discovery Visit Iowa

Just seven years before Dubuque's death, a milestone in Iowa's history had taken place. The Louisiana Purchase would nearly double the size of the United States, a new nation that was barely twenty-two years old and had previously extended west to the Mississippi River.

Wars and financial difficulties prompted French military and political leader Napoleon Bonaparte to sell the Louisiana Territory for $15 million to the United States. President Thomas Jefferson purchased nearly 828,000 square miles of land west of the Mississippi River to the Rocky Mountains.

It was the real-estate deal of the nineteenth century, as the massive territory was purchased for less than three cents per acre. (Even this bargain of epic proportions was controversial at the time, however, since the fledgling United States didn't have enough financial resources to buy the Louisiana Purchase outright and had to borrow money from European banks.)

Part or all of nearly fifteen states would be created from the Louisiana Purchase, including Iowa, but first the boundaries of the newly acquired territory had to be determined. Jefferson commissioned Captain Meriwether Lewis and Lieutenant William Clark to lead the Corps of Discovery into the vast northwest regions of the Louisiana Purchase. The corps departed from St. Louis in May 1804 by keelboat with more than thirty men and Lewis's Newfoundland dog, Seaman. The mens' orders were to record information about Native American tribes living in the area, identify the best places for forts and trading posts and document the native plants, animals and land included in the region.

Lewis and Clark had to plan for times when wild game would be unavailable or in short supply. Their keelboat was stocked with nearly seven tons of dry goods, including flour, salt, coffee, pork, corn, sugar, beans and lard, according to the Public Broadcasting Service's History Kitchen website, which noted that the men took turns cooking meals. Tradable goods were brought along to use as gifts in exchange for help from Native American tribes. This proved to be a wise decision, and the Native Americans became invaluable partners when food was scarce.

The travelers replenished their food supply along the way as best as they could through hunting and gathering. When wild game was plentiful, each man consumed up to nine pounds of meat per day. Protein was vital, giving the men the strength to manage the long, treacherous trip by water and on foot across a vast, unknown wilderness. The types of animals the men

harvested for meat, from deer to bison, reflected the season and terrain of the regions they encountered.

On August 10, 1804, the Corps of Discovery arrived at the area where Lewis and Clark State Park near Onawa, Iowa, now lies. (On display at Lewis and Clark State Park is a full-sized reproduction of Lewis and Clark's keelboat.) While the group continued to sail up the Missouri River and on to the Pacific Ocean before completing its mission in September 1806, not all the men returned safely. In the summer of 1804, when the Corps of Discovery traveled the Missouri River's twists and turns along what would become Iowa's western border, Sergeant Charles Floyd became gravely ill on August 19 near the present-day site of Sioux City. Floyd's illness was considered to be a "bilious cholic," although historians suspect a ruptured appendix caused Floyd's death on August 20, 1804.

Floyd was buried on a bluff overlooking the Missouri River. In 1901, a one-hundred-foot-high sandstone obelisk, similar to the Washington Monument in Washington, D.C., was dedicated on Memorial Day to honor Floyd. Remarkably, Floyd's death was the only fatality among expedition members during the two years, four months and nine days of their transcontinental odyssey.

DRAGOONS EXPLORE THE DES MOINES RIVER VALLEY

While Lewis and Clark visited western Iowa in 1804, it would take decades before this part of Iowa was settled. Iowa's oldest cities are found along the Mississippi River. Not only were these river towns the commercial hubs of pioneer Iowa, but Burlington also served as the capital of the territory at one time.

Beyond the Mississippi, pioneers began heading west into the new Iowa territory in larger numbers by the mid-1830s, following the Black Hawk Purchase. They came on foot, on horseback and in covered wagons. With no roads or bridges to rely on, they followed Native American trails in their search for a place to call home.

To help keep order along the frontier, the U.S. government sent three companies of Dragoons to the territory. After building Fort Des Moines on the Mississippi River near present-day Montrose in southeast Iowa, these U.S. cavalry soldiers headed north in early June 1835 to conduct the first official exploration of the Des Moines River Valley and find places to establish military forts.

Under the command of Lieutenant Colonel Stephan Kearney, the Dragoons included men like Captain Nathan Boone (son of Daniel Boone). This small group of U.S. soldiers on horseback explored the Des Moines River Valley as far as present-day Des Moines and then up to Fort Dodge and beyond. (Modern highway signs mark their route as the Dragoon Trail.)

Travel was slow for most of the expedition due to the swampy nature of Iowa's prairies. The Dragoons took along a cow to provide milk and cream as the men traveled. One day, the horses rode through beds of ripe wild strawberries so thick that their hooves were stained bright red at the end of the day. That night, the soldiers picked berries for supper and feasted on fresh strawberries and cream. (On a side note, Iowa today is home to the world's largest strawberry, which graces the small northeast Iowa town of Strawberry Point. The fifteen-foot-tall painted fiberglass sculpture has been displayed on a post in front of city hall since the 1960s.)

During the journey, Lieutenant Albert Lea kept a journal that described the events of each day. He noted that the general appearance of the country was one of great beauty. He described Iowa as one grand rolling prairie with numerous navigable streams. His reports helped provide some of the first reliable geographical information of central Iowa.

Meskwaki Tribe Purchases Land in Iowa

Some of the early inhabitants of Iowa were firmly established by the time the Dragoons arrived. These included members of the Meskwaki tribe, who had migrated to the Iowa territory after they were forced to abandon their villages in east-central Wisconsin starting in the 1730s, according to the University of Iowa.

The Meskwaki (a tribal name meaning "Red Earth People") were historically a seminomadic culture, electing to live together in a single concentrated area during the summer months but scattering into smaller, independent areas throughout the winter season. The Meskwaki economy combined hunting, gathering and agriculture. Since the Meskwaki were not totally dependent on one single way of making a living, they could better adapt to changes that devastated many other tribes.

This adaptability would prove invaluable as settlers pushed west into the Iowa territory. Treated by the U.S. government as a single "Sac and Fox Tribe," the Meskwaki and the Sauk lost all lands in Iowa through a series of treaty cessions. By 1845, most had been removed to a reservation in east-

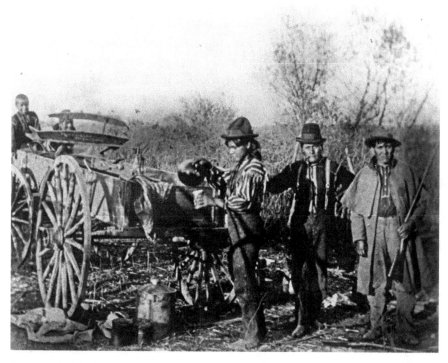

By 1800, the Meskwaki had become firmly established in Iowa. The Meskwaki economy combined hunting, gathering and agriculture. Meskwaki from Tama frequently visited the Amana Colonies in the early 1900s. *Courtesy of Amana Heritage Society.*

central Kansas, although some Meskwaki remained in Iowa and others soon returned. In 1856, the Iowa legislature enacted a law permitting the Meskwaki to remain in Iowa, and in 1857, the Meskwaki purchased the first eighty acres of their current settlement in Tama County.

Today, the Meskwaki (called the Sac and Fox Tribe of the Mississippi on the Meskwaki Nation's website) is the only federally recognized Native American tribe in Iowa. They continue to play a unique role in Iowa's cultural and culinary heritage, much like the descendants of the European immigrants who sought a new life in Iowa when they began settling on the prairie more than 150 years ago.

IMMIGRANTS INFLUENCE IOWA'S FOOD TRADITIONS

Hundreds of thousands of pioneers and immigrants from many parts of Europe and beyond flocked to Iowa in the nineteenth and early twentieth centuries in search of a better life, whether that meant economic opportunity, religious freedom or the chance to create a utopian society. These newcomers brought a variety of unique food traditions with them and transformed Iowa's culinary history.

Some immigrants, like the French Icarians, were motivated by ideological ideals when they settled in America. The new state of Iowa, specifically Adams County, became the promised land for French men and women pursing their dream to create a communal, utopian society where everyone was equal. By some accounts, their Icaria Colony in southwest Iowa was the longest-existing, nonreligious, purely communal experiment in American history.

The first Icarian party arrived in Iowa in 1852. They purchased about three thousand acres of land from the United States government at $1.25 per acre to build their new colony near Corning. Living conditions in the untamed lands of southwest Iowa were often harsh. Log houses, some without wood floors or windows, were the French settlers' only shelter against the brutal winter. Most of the Icarians' land was unfenced, unbroken prairie, and there was not one settler along the trail before they reached Icaria, according to some reports.

Supplies for the colony often had to be hauled overland for hundreds of miles. Only a few basic ingredients, including milk, butter, corn bread

and bacon, formed the daily menu. As a communal society, the Icarians worked together on the farms and ate together in a communal dining hall, where evening meals were sometimes followed by music or lectures (spoken in French).

Little by little, living conditions in the colony improved as the Icarians managed to establish a fairly successful agricultural enterprise. When wool prices skyrocketed with the outbreak of the Civil War, the Icarians thrived by selling wool and other supplies to the Union army.

While the war ended in 1865, trouble was brewing in the Icaria Colony by the 1870s. Much of the conflict revolved around little gardens, according to an April 1921 article in the Iowa history journal *The Palimpsest*. Earlier in the history of the Icarian community in Iowa, each family had been permitted to cultivate a little garden around their log house where flowers might be raised. Some families had planted vines and even fruit trees. Now that these plants were bearing fruit, the more radical members of the colony could not tolerate this violation of their rules against private property. The possessors of the gardens, however, clung to their little plots of ground. It wasn't much, but it was theirs.

The authorities tried to settle the quarrel with a compromise. As each family moved from their log house to a new frame house, their little garden was to be given up. There would be no simple resolution to this dispute, however, which triggered open hostilities. The radicals claimed that the community had violated its constitution and announced their intent to withdraw. They also advocated an aggressive style of communism and appealed to a circuit court to revoke the charter granted to the community in 1860 on the grounds that Icaria was really a communist establishment instead of an agricultural society, as the articles of incorporation provided.

By 1879, a group of younger, progressive colony members had split from the older, more conservative members. This marked the beginning of the end for the Icarians' utopian experiment in Iowa. In 1898, members voted to end the colony. By then, it consisted mostly of elders who could no longer continue the hard work of operating the colony. The Icarian movement in America was over.

The legacy of the Icarian movement endures, however. The French Icarian Colony Board of Trustees was formed in recent years and has been rebuilding the French Icarian Village on a portion of original Icarian land east of Corning. The 1878 refectory (communal dining hall) and 1860 one-room Icaria school have been restored for tours and research.

History comes to life at the French Icarian Village through events like the annual Fete de Mais (Festival of Corn), which is held in the fall. The original Fete de Mais was a celebration held by the Icarians each fall after all the crops were harvested. The feast was served in the communal dining hall to everyone who came to help on the final day of corn harvest. In late September 2015, the *Creston News Advertiser* promoted the French Icarian Village's fourth annual Fete de Mais, which included a four-course French supper featuring flavors of the Alsace region. It's a modern taste of the French Icarians' quest for utopia in Iowa.

Amana Colonies Maintain Rich History in Iowa

The Icarians weren't the only communal society to play a role in Iowa's culinary history. The famous Amana Colonies in eastern Iowa were also founded on communal principles, but unlike the Icarians, the Amanas had a strong religious component.

By the 1700s, people across northern Europe had become dissatisfied with the rituals and intellectualism of the Lutheran Church and had begun to rebel and separate from the church. Adherents to a new faith called the Community of True Inspiration formed their own self-reliant communities. Known as the Inspirationists, these men and women and their families found refuge in central Germany. Persecution and an economic depression in Germany in the 1830s, however, forced the community to search for a new home.

Hundreds of Inspirationists immigrated to America in 1843–44 in search of religious freedom. They pooled their resources and established a community named Ebenezer near modern-day Buffalo, New York. All property was held in common. Farms and factories were established, and the community of nearly 1,200 people prospered. When more farmland was needed for the growing community, the Inspirationists looked to Iowa, where attractively priced land was available. A committee was sent to inspect land in Iowa in the mid-1850s.

The Iowa River Valley proved particularly promising. Here, the men found acres of rich soil, good timber, water, limestone, sandstone and clay necessary for establishing a new community. The leaders chose the name Amana (meaning "remain true") from Song of Solomon 4:8. Starting in 1855, six villages were established a mile or two apart, including Amana,

East Amana, West Amana, South Amana, High Amana and Middle Amana. The village of Homestead was added in 1861, giving the Amana Colonies access to the railroad.

Each village had its own school, farm and craft industries to make it virtually self-sufficient. The communal way of life was continued in Amana, much like it had been in Ebenezer. All property was held in common. Families were assigned housing in buildings owned by the Amana Society. Each individual worked at a designated job. Religious life was the strong unifying factor.

In the seven villages, residents received a home, medical care, meals, all household necessities and schooling for their children. Property and resources were shared. Men and women were assigned jobs by the village council of brethren. No one received a wage. Farming and the production of wool and calico supported the community, but village enterprises

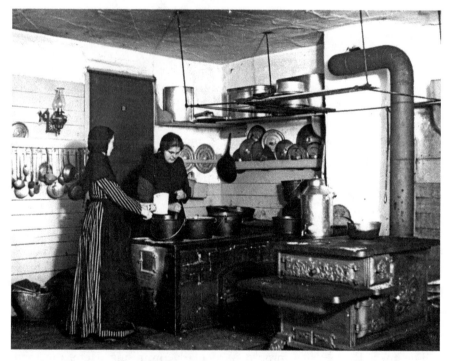

These women are shown working in an Amana communal kitchen circa 1900. From the late 1850s to the early 1930s, more than fifty communal kitchens in the Amana villages in eastern Iowa provided three daily meals, as well as a midmorning and midafternoon snack, to all the members of the communal society. These kitchens were well supplied by the village smokehouse, bakery, icehouse and dairy, as well as the orchards, vineyards and huge communal gardens maintained by the villagers. *Courtesy of Amana Heritage Society.*

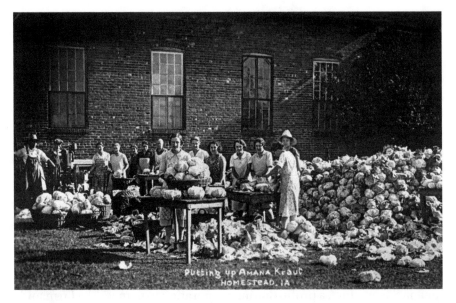

Huge gardens in the Amana Colonies provided plenty of fresh produce for the communal kitchens. The women shown here at the Homestead kitchen are preparing cabbage to make sauerkraut in the early twentieth century. *Courtesy of Amana Heritage Society.*

from clock making to brewing were vital. Well-crafted products became a hallmark of the Amana Colonies, which are still known for exceptional wines and more.

People were called to work before dawn by the gentle tolling of the bell in the village tower in old Amana, where the pace of life was much different than today. More than fifty communal kitchens provided three daily meals, as well as midmorning and midafternoon snacks to all colonists. These kitchens were operated by the women of the Amana Colonies and were well supplied by the village smokehouse, bakery, icehouse and dairy, as well as the orchards, vineyards and huge communal gardens maintained by the villagers.

During the growing season, there was plenty of work to do in the gardens and kitchens, from planting and harvesting to preparing and storing vegetables from cabbage to turnips. Around 1900, for example, it wasn't unusual for the communal kitchens in just one Amana village to produce more than four hundred gallons of sauerkraut.

It took a lot of food and labor to sustain the villages within the Amana Colonies. Children attended school six days a week, year round, until age fourteen. Boys were then assigned jobs on the farm or in the craft shops, while girls were assigned to a communal kitchen or garden. Work and faith

were intertwined in the villages, where the Inspirationists attended worship services eleven times per week.

Times were changing by the early twentieth century, however. Improved communications and transportation in the 1920s began to exert their influence on the Amana Colonies. In addition, the collapse of the American economy following the stock market crash of October 1929 left no aspect of daily life untouched. The Great Depression and disastrous farm economy made the isolated communal life in Amana socially and economically impossible. In the early 1930s, Amana set aside its communal way of life. A strong desire on the part of residents to maintain their community finally propelled the change, according to an Amana history shared by the Amana Colonies Convention and Visitors Bureau. By 1932, the communal way of life was seen as a barrier to achieving individual goals. Rather than leave or watch their children leave the community, the people of the Amana villages changed.

Members voted to abandon the communal system and established the Amana Society Inc., a profit-sharing corporation to manage the farmland, mills and larger enterprises. Private enterprise was encouraged. While this separated the economic aspect of the community from the church, the Amana Church Society continued to be the religious foundation of the community.

Today, the seven villages of the Amana Colonies are among the state's most popular tourist attractions. Declared a National Historic Landmark in 1965, the Amana Colonies attract hundreds of thousands of visitors annually who come to experience a place where the past is cherished and hospitality is a way of life. The streets of the Amana Colonies—lined with their historic brick, stone and clapboard homes; their flower and vegetable gardens; and their lanterns and walkways—recall the Amana of yesterday.

Many museums are available for tours, including the communal kitchen in Middle Amana. Preserved just as it was on the day in 1932 when the last communal meal was served in the colony, the communal kitchen lets you step back in time. Guides explain kitchen routines and share insights on communal life.

Guests can also enjoy a satisfying taste of Amana history and hospitality at the famous Ox Yoke Inn, a full-service restaurant founded in 1940 in the village of Amana. The Ox Yoke Inn's nationally recognized reputation of fresh, quality food served family style reflects the restaurant's old-world signature dishes. The Ox Yoke Inn serves traditional German and American favorites at breakfast, lunch and dinner, as well as on the Sunday brunch buffet.

Glimpses of the past are also preserved in some of the gardens in the Amana Colonies. With the passing of the old order in 1932, the number of the society's large vegetable gardens and orchards dwindled, but Larry Rettig and his wife, Wilma, still grow some of the colonies' heirloom varieties in their fourth-generation South Amana vegetable garden.

In 1980, they founded a seed bank to preserve heirloom plants for future generations. In his 2013 book, *Gardening the Amana Way*, Rettig's chapters on modern vegetable and flower gardening in today's Amana Colonies showcase his Cottage-in-the-Meadow Gardens, now listed with the Smithsonian's Archives of American Gardens. Old intermingles with new across Rettig's gardens, as heirloom lettuce keeps company with the latest cucumber variety. It's a living tribute to the unique history of Amana Colonies and one of America's longest-lived communal societies.

Rhubarb Offers a Taste of Spring

A taste of the Amana Colonies also lives on in recipes for traditional dishes including radish salad, dumpling soup, apple bread and strawberry-rhubarb pie. Just as strawberry-rhubarb pie was a classic dessert from the Amana Colonies' communal kitchens, it remains a popular treat in many Iowa kitchens.

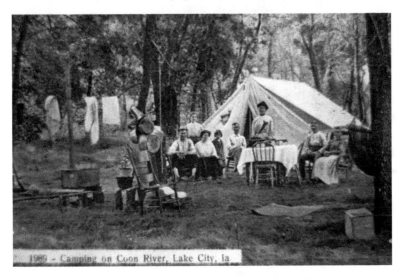

1989 - Camping on Coon River, Lake City, Ia

Picnics and camping have been favorite pastimes for generations of Iowans. Recreation in the good old days before automobiles often included camping along the Raccoon River near Lake City. Camping and picnicking in the late 1800s and early 1900s look like rather formal affairs by today's standards. *Courtesy of Central School Preservation.*

Rhubarb is a sure sign of spring in Iowa. Although it is classified as a vegetable, rhubarb (also known as pie plant) is used as a fruit because its high acidity gives it a tart flavor. While rhubarb doesn't grow in more temperate climates, this hardy perennial thrives in Iowa. Although the leaves contain poisonous oxalic acid, the deep red stems can be harvested in the spring. For generations, many Iowa farm families and gardeners have used rhubarb in a variety of dishes, from sauce to jam to cakes and pies, that often accompany meals and special events like picnics.

Rhubarb pairs especially well with another springtime favorite: strawberries. This award-winning recipe came from Marianne Carlson of Jefferson, who won first place overall in the 2013 Machine Shed Pies competition at the Iowa State Fair.

RHUBARB-STRAWBERRY PIE

2 cups sliced rhubarb
2 cups sliced strawberries
1¼ cups granulated sugar
3 tablespoons tapioca
2 tablespoons butter or margarine
pastry for double-crust 9-inch pie
milk
granulated sugar

Combine rhubarb, strawberries, sugar and tapioca; let stand 15 minutes. Pour into pastry-lined pie pan. Dot with butter or margarine. Top with pastry crust. Flute and crimp edges of pastry. Cut slits in top of crust to vent steam. Brush crust with milk, and sprinkle with sugar. Bake in 400-degree oven for 15 minutes. Reduce heat to 350 degrees, and bake 40 minutes more, until top is lightly browned and filling is bubbly.

TASTE THE WORLD IN IOWA

While the Amana Colonies brought a taste of Germany to Iowa, other nineteenth-century immigrants also preserved a taste of their homeland after their arrival.

Danish immigrants, who settled in communities ranging from Elk Horn and Kimballton in southwest Iowa to Ringsted in northern Iowa, brought many holiday traditions that revolved around food, from apple cake to æbleskivers (traditional pancake puffs in the shape of a sphere).

Dutch settlers who arrived as early as 1847 in Marion County in southeast Iowa brought with them a passion for religious freedom and an affinity for producing high-quality meat products and baking delicious pastries. This culinary tradition lives on in Pella, home of the Vander Ploeg Bakery and Jaarsma Bakery. The Jaarsma Bakery has been offering delicious "Dutch Treats" since 1898, when it was founded by Harmon Jaarsma, who used recipes he brought with him as an immigrant from Holland.

More than a century ago, Harmon had two brick ovens fired with wood. After the ashes were brushed out, bread was put in to bake, followed by buns, Dutch Letters and cookies. Back then, Dutch Letters were made only as a special treat for Sinterklaas Day (St. Nicholas Day) in early December. Today, Dutch Letters are baked year-round and are typically shaped into an "S" for "Sinterklaas."

Family baking at the Jaarsma Bakery has been carefully passed on for four generations. The bakery is now owned and operated by Harmon's great-granddaughter, Kristi, and her husband, Dave Balk. The bakery produces not only the famous Dutch Letters but also other Jaarsma Dutch specialties, including speculaas (Dutch spice cookies) and boter koek (almond butter cake). The treats are a must-have during Pella's annual Tulip Festival in early May, as well as year round. (Visitors to northwest Iowa can also enjoy a taste of the Netherlands in Orange City, home to the Dutch Bakery.)

Pastries were also a beloved culinary tradition that Czech/Bohemian immigrants brought to Iowa. Kolaches are often associated with Cedar Rapids, which was home to many Czech immigrants and boasts the National Czech & Slovak Museum & Library. Kolaches, which are tender pastries filled with sweetened fruit or cheese, are also a part of the culture in the Pocahontas area. "We often serve six hundred kolaches or more in two hours and usually have less than a dozen left when we're done," said Diane Keith of Fort Dodge, who helps serve the kolaches and

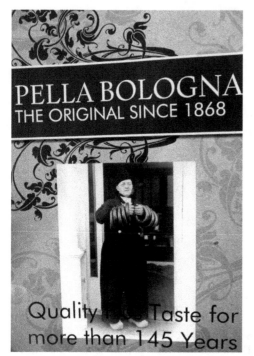

Left: Not only is Pella known for its Dutch Letters, but Ulrich Meat Market has sold the famous Pella bologna since 1868. *Author's collection.*

Below: In 1912, it was quite an event when Guenthers' Grocery in Lake City received a load of fifty-pound flour sacks. This photo shows delivery driver Sam Redenius after he had backed up the mules, Jack and Jenny, to the south back door. The man on the back of the wagon is Charles Bauman. Standing in the doorway is J. Walter Guenther, while Robert Fickle is standing beside the wagon. *Courtesy of Jolene Schleisman.*

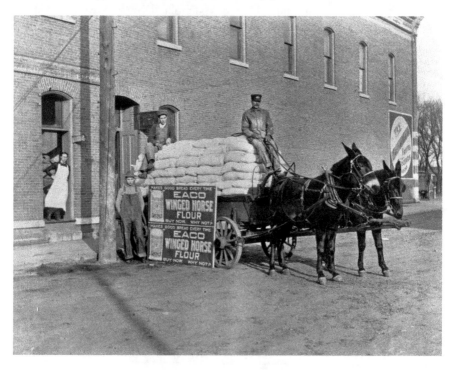

coffee at historic SS. Peter and Paul Church during Heritage Days each summer in Pocahontas.

Kolaches have long been part of the culture in the Pocahontas area, starting in the 1870s, when Czech/Bohemian families began moving into the county to farm. Unlike the open-faced kolaches that are common in eastern Iowa, Pocahontas-area cooks pull the corners of the dough over the filling before baking their kolaches. These distinctive kolaches have long been associated with SS. Peter and Paul Church, which became the first Catholic church in Pocahontas County when it opened in 1883. "The church used to host a Fourth of July picnic each year, and kolaches were always part of the meal," said Diane, who was married in 1967 in the church, which served the community until the building closed permanently in 1983.

Kolaches weren't just ubiquitous at church dinners. They also became a beloved comfort food and a tie to cultural traditions for families. "The Kopriva side of my family had an especially strong tradition of making kolaches," said Diane, who grew up on a farm northeast of Pocahontas. "They weren't just for holidays or special occasions, either."

Many Iowa families of Czech/Bohemian descent have handed down their favorite kolache recipe from generation to generation. Some kolaches feature a simple, straightforward flavor, while others have a more complex flavor due to a hint of spice or lemon zest in the dough. "Kolaches are all customized to what the family likes," said Betty Hallberg of Pocahontas, who used to watch her mother and grandmother make them. "If a recipe calls for mace, for example, you could substitute nutmeg or leave the spice out entirely."

One of the keys to any kolache, however, is the texture of the dough. "I like my dough a little sticky; otherwise the kolaches can get a little dry," said Betty, who uses plastic templates cut from whipped topping cartons to form kolaches so uniform they look like they came off an assembly line.

Betty mixes things up, though, when it comes to the filling. She likes prune and apricot and often makes her own filling. This traditional recipe from eastern Iowa (specifically the Kettel House Bakery and Café in Marion) offers a taste of this popular Czech pastry.

Kolaches

6 cups milk
3 tablespoons yeast
2 tablespoons salt
3 eggs
2 cups granulated sugar
11–12 cups flour, or more as needed
1 cup vegetable oil
4 cans of pie filling (any flavor you like)

Scald milk. Cool and add yeast and salt. Let mixture sit 5 minutes. Add eggs and sugar. Beat together.

Add 6 cups of flour; stir. Add 5 to 6 more cups of flour and combine the flour into the mixture. Add vegetable oil. Dough should pull away from the sides of the bowl and form an elastic ball. Place dough in greased bowl. Allow dough to rise until it doubles in size. Form kolaches by taking pieces of dough and forming them into 3- by 3½-inch circles. Place kolaches on a pan to rise until the kolaches have doubled in size. Use the bottom of a measuring cup to make an indentation in the center of each kolache and add pie filling. Let rise.

Bake kolaches at 350 degrees for 10 to 15 minutes. Makes 60 kolaches.

Through the years, many other immigrant groups from Europe and beyond made Iowa their home and contributed to the state's culinary history. Italian immigrants tended to settle in metropolitan areas, including the south side of Des Moines, bringing along their recipes for Italian sausage and beloved pasta dishes. Irish immigrants settled in scattered pockets across Iowa, including Emmetsburg, which hosts an annual St. Patrick's Day celebration complete with Irish stew and other culinary traditions.

Perhaps the most distinctive ethnic culinary traditions that live on in Iowa come from the Scandinavians, especially the Norwegians. The northeast Iowa town of Decorah revels in its rich Norwegian heritage and celebrates its annual Nordic Fest, where krumkake is king. This rich, delicate waffle cookie made of flour, butter, eggs, sugar and cream is served at many family dinners and bake sales.

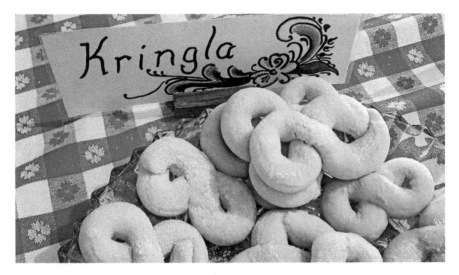

Some of the most distinctive ethnic culinary traditions that live on in Iowa come from the Scandinavians. During the Christmas holidays, treats like kringla, krumkake and lefse can be found at various church suppers and other gatherings. *Author's collection.*

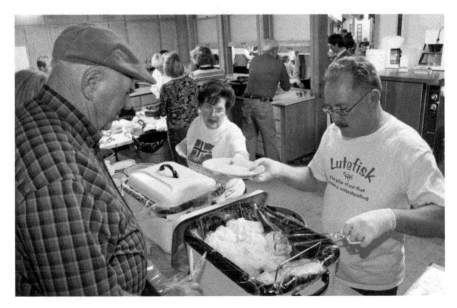

Lutefisk dinners are a Norwegian tradition that have drawn big crowds to places like the Webster County town of Badger (shown here). Grace Lutheran Church in Hanlontown, not far from the Minnesota border, also hosts its annual lutefisk dinner the Thursday before Thanksgiving each year. With its gelatinous texture and distinctive flavor, lutefisk is an acquired taste for most people. *Author's collection.*

Krumkake and other popular Scandinavian treats, including kringla (a light, fluffy cookie shaped like a pretzel) can also be found at Our Savior's Lutheran Church in the north-central Iowa town of Callender, where members have been hosting their annual Christmas Fair since the late 1950s. Along with krumkake, guests flock to the church dining hall for the ever-popular lefse. For many Norwegian Americans, Christmas cheer is wrapped up in lefse. Similar to a flatbread or soft tortilla, lefse is made mostly out of mashed potatoes and is cooked on a special lefse grill. This "Viking soul food" is usually spread with butter and sugar. Take one bite, and you'll discover there's something so comforting about this soft, starchy treat.

People in some parts of rural Iowa can't wait until the holidays to enjoy other Norwegian fare, including the infamous lutefisk. This "piece of cod that passes all understanding" has been the star of many a meal at Lutheran church dinners from Badger in Webster County to Grace Lutheran Church in Hanlontown, not far from the Minnesota border. Grace Lutheran Church hosts its annual lutefisk dinner the Thursday before Thanksgiving each year. Lutefisk (pronounced *loot*-uh-fisk) is a traditional Nordic dish of dried cod that has been soaked in a lye solution to rehydrate it. The cod is rinsed with cold water to remove the lye. The fish is then tied in cheesecloth and boiled in water. Lutefisk is often served with butter or cream. With its gelatinous texture and distinctive flavor, lutefisk is an acquired taste for most people. "We feed more than four hundred people, seating our guests at 11:00 a.m., noon, 5:00 p.m. and 7:00 p.m.," according to Suzzanne Rye, who reports that many Grace Lutheran Church guests wear their Norwegian sweaters for the event.

She and her husband, Clayton, help with the annual dinner, which wouldn't be complete without mashed potatoes, corn, rutabaga, cranberry salad, meatballs and gravy, along with rommegrot (a traditional Norwegian pudding/porridge made with milk and cream) and Norwegian pastries (including lefse) for dessert. Here's the lefse recipe from the Grace Lutheran Church's cookbook.

LEFSE

3 ½ cups cooked, mashed potatoes (Russet potatoes work well)
¼ cup melted butter
2 tablespoons sugar
1 teaspoon salt
¼ cup half-and-half
1 cup flour

Cook potatoes until just done. Drain. Mash potatoes, then put them through a potato ricer. Add the rest of the ingredients, except the flour. Cool for a few hours or overnight. When ready to bake, mix in the flour. Roll lefse on a well-floured pastry cloth. Bake on lefse grill. Makes 12 rounds of lefse.

FARM-FRESH FOODS

Iowa's cultural heritage, food traditions and culinary history are closely intertwined with the land. Since the territory of Iowa was opened up to settlers in the mid-1830s, agriculture has been the heart of Iowa. Many of the hundreds of thousands of immigrants who settled in Iowa were lured by the state's rich, fertile soil and the chance to farm. These hardy pioneers transformed the prairie into one of the most productive agricultural areas in the world.

While a large portion of Iowans lived on farms and in small towns for decades, this began to change by the 1920s as farming became more mechanized. The trend toward more mechanization and greater urbanization gained momentum in the 1950s. The 1980s Farm Crisis also accelerated the depopulation of rural Iowa.

While fewer than 5 percent of Iowans farm today, they maintain Iowa's status as a farm and agriculture powerhouse worldwide. Iowa has nearly eighty-nine thousand farms, and more than 97 percent of these farms are owned by families. Many of these families follow in the footsteps of their ancestors and continue to produce crops and livestock on the same land. Since the American Bicentennial of 1976, the Iowa Department of Agriculture and the Iowa Farm Bureau Federation have recognized more than fifteen thousand families with the Century Farm award, which honors people who have owned the same Iowa farmland for 100 years or more. Families who have owned the same farmland for 150 years or more are eligible to receive the Heritage Farm award.

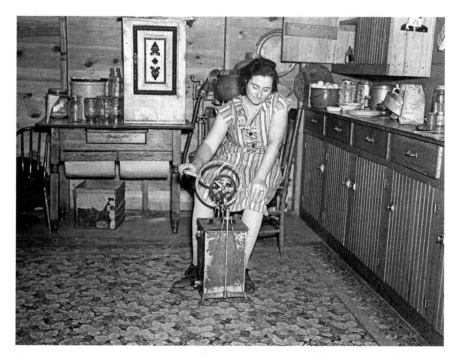

This Emmet County farm woman was hard at work churning butter in the 1930s. Many farm and household chores demanded physical labor in the days before rural electrification began transforming the countryside in the late 1930s. *Courtesy of the Library of Congress.*

Today, Iowa farms grow more corn and soybeans, raise more pigs and produce more eggs than any state in the nation. In fact, the average American farmer feeds about 154 people worldwide, according to the Iowa Farm Bureau Federation.

All this bounty is a direct reflection of the rich, black soil that makes Iowa ideal for food production, from row-crop farming to backyard gardening. In Iowa City, gardens grow history at the Plum Grove Historic Site. Heirlooms from Green Moldovan tomatoes to St. Valery carrots and Cimarron lettuce would have been familiar to Plum Grove's original inhabitants, Robert Lucas (who served as the first governor of the Iowa Territory from 1838 to 1841) and his wife, Friendly. To showcase these flavors of the past, local master gardeners hosted a Taste of Plum Grove in 2015. The event featured an array of recipes from the mid-1800s that showcased the garden's produce, some of which can be traced to Seed Savers Exchange in Decorah, which preserves heirloom seeds.

Seed Savers Exchange has offered a unique resource for decades. It was founded in 1975 by Diane Ott Whealy and Kent Whealy after Diane's

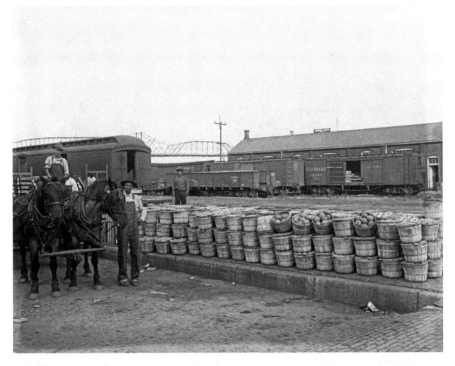

For decades, sweet, juicy Muscatine melons have been grown in the "garden spot of Iowa." The sandy soil near the Mississippi River south of Muscatine is ideal for fruit and vegetable production. In years past, the melons were shipped to various markets via the railroad. *Courtesy of Musser Public Library, Muscatine.*

grandfather entrusted to the pair the seeds of two garden plants, including the "German Pink" tomato and "Grandpa Ott's morning glory." These seeds, brought by Grandpa Ott's parents from Bavaria to Iowa in the 1870s, became the first two varieties in the collection. Diane and Kent Whealy went on to form a network of gardeners interested in preserving heirloom varieties and sharing seeds. Today, with thirteen thousand members and twenty thousand plant varieties, Seed Savers Exchange makes its home on 890 scenic acres in Winneshiek County near Decorah.

Farther south in eastern Iowa, Muscatine melons continue to preserve a slice of Iowa's culinary heritage. What makes a Muscatine melon taste so good isn't just the type of muskmelon, but where it is grown. The sandy soil near the Mississippi River south of Muscatine is ideal for fruit and vegetable production. Once called "the garden spot of Iowa," this truck farming region has produced a wide variety of fruit and vegetable crops for more than 150 years, but the area is best known for its sweet, juicy melons.

At one time, the golden, fragrant melons could be found at roadside stands at almost every farm or were sold from the back of pickup trucks. Today, many growers sell their melons at farmers' markets around the region and in eastern Iowa grocery stores.

Seed Stories from Southwest Iowa

In the opposite corner of Iowa, two of the state's most prominent seed and nursery businesses took root more than a century ago, thanks to Henry Field and Earl May. Field grew where he was planted in Page County. The young entrepreneur would carry baskets of produce from his family's farm to Shenandoah, where he'd go door to door selling vegetables, strawberry plants and seeds harvested from his family's garden.

After graduating from Shenandoah High School in 1889 and attending Western Normal College in Shenandoah, Field decided to focus on the seed business. He established a truck farm on the edge of Shenandoah and produced such bountiful yields that people began seeking out his seeds. In 1899, he self-published a four-page catalogue to broaden the market for his seeds. By 1907, Field had incorporated the business as the Henry Field Seed Company. He grew the business beyond the boundaries of Shenandoah by expanding into a mail-order company.

When radio came to the Midwest in the early 1920s, Field became a pioneer by building the KFNF radio station at his Shenandoah seedhouse in 1924. Programming consisted of live music, hymns, discussions of agricultural issues and chats from Henry himself, who talked about the weather, his garden, his business and whatever else struck his fancy.

Only a few hundred radio stations were operating in the country at the time. Field's broadcasts from Shenandoah made him a trusted resource for farmers and gardeners throughout Iowa and the Midwest. With quality products and savvy marketing that included the slogan "Seeds that Yield Are Sold by Field," the Henry Field Seed Company become one of the most famous and successful mail-order seed suppliers in the nation.

Another local nurseryman and seed supplier, Earl May, followed suit in 1925 by establishing his own radio station, KMA, in Shenandoah. May would become Field's most spirited competitor and, by adapting some of Field's innovative business strategies, would help make Shenandoah a community widely recognized for its nurseries and seedhouses.

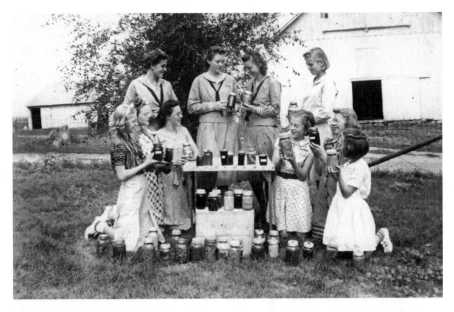

For generations, canning fresh fruits and vegetables was a culinary art that many young girls learned from their mothers and their local 4-H clubs. This group displayed their handiwork outside a barn on this Calhoun County farm. It's likely that some of the seeds for their produce could have come from the Henry Field Seed Company or Earl May in Shenandoah. *Courtesy of County County Extension.*

Earl May had founded his company in 1919. A natural-born salesman, he quickly built a successful mail-order and retail seed and nursery business based in Shenandoah. After starting out with just handful of seed and nursery catalogues in 1919, more than 2 million were mailed annually during the peak years of his mail-order business.

In the early 1920s, May was captivated by the power of radio to reach thousands of people. He traveled to Omaha, Nebraska, to broadcast his program. After two years, he decided to build his own radio station in Shenandoah. In 1925, KMA went on the air and became one of the most popular stations in the country, broadcasting homespun farming and gardening talks.

The radio show helped boost May's catalogue sales. On cold winter nights, gardeners could browse the catalogues filled with lush, blooming plants and dream of receiving seeds and nursery stock ready for spring planting. Each year, thousands of listeners also visited the Mayfair Auditorium, the spacious, movie palace–like auditorium and home of KMA, so they could meet May and watch the live broadcasts.

As May wrote in one of his spring catalogues, "Be sure to come—bring your whole family. Remember, we do not put on any style here. If you are in your working clothes and decide to come, why come ahead, because you'll find me here in my working clothes, too. Come as soon as you can, for I promise you will have a good time and you will be glad you made the trip."

In addition to radio broadcasting, May wrote the copy for his company's mail-order catalogues and his *Nursery and Seed News*. The publications were filled with product and planting advice, as well as personal anecdotes that made readers feel like real friends. When banks failed during the Depression, May often told his farm seed customers to order and plant the seed they needed and pay him whenever they could. Such kindnesses earned him a reputation as a friend and humanitarian throughout the country.

May Seed & Nursery Company's business was 90 percent mail order for many years, until the first brick-and-mortar retail store outside of Shenandoah was opened in Lincoln, Nebraska, in 1930. The May Company continued to add more stores across Iowa and the Midwest. In 1938, the decision was made to operate all stores on a year-round basis. Fertilizers, insecticides, tools and other items were added to the existing merchandise line, establishing the foundation for today's Earl May Nursery & Garden Centers.

Although May died in 1946, his legendary gardening expertise lived on with the garden centers that bear his name. The mail-order catalogue also remained a powerful sales tool for the business for many years, although it was dropped in 1991 so the company could concentrate on its retail nursery and garden centers.

Today, Shenandoah remains the corporate headquarters for Earl May Nursery & Garden Centers, which are renowned for providing high-quality plants, seeds and gardening supplies in the Midwest and are among the top ten garden centers in the nation.

Jessie Field Shambaugh and the Birth of 4-H

Men weren't the only leaders breaking new ground in gardening and Iowa's culinary history during this era. Henry Field's sister Jessie Field Shambaugh guided the formation of today's 4-H clubs during her tenure as a country schoolteacher in southwest Iowa. At the turn of the twentieth century, "Miss Jessie" was a woman far ahead of her time. An innovative teacher,

she introduced basic science classes in addition to the "3 *R*s" in the country school curriculum. She was a strong proponent of relating school lessons more closely to life on the farm and in the rural home.

In the spring of 1901, Miss Jessie's students at the Goldenrod School near Clarinda planted and tended a garden in the schoolyard. On alternate days after school, Miss Jessie met with the older boys to study corn production and met with the girls to discuss the art and science of homemaking. In the book *The Very Beginnings*, Miss Jessie (who was called "the Corn Lady" by her students) recalled that her ag lessons were simple, because she had no lesson plans or scientific leaflets to rely on. "The eagerness and enthusiasm which was displayed by these groups in these after-school hours as I told them what I knew about our main Iowa crop—corn—made me realize that here was a subject not in the school's curriculum, but one which was greatly needed in our vast agricultural area."

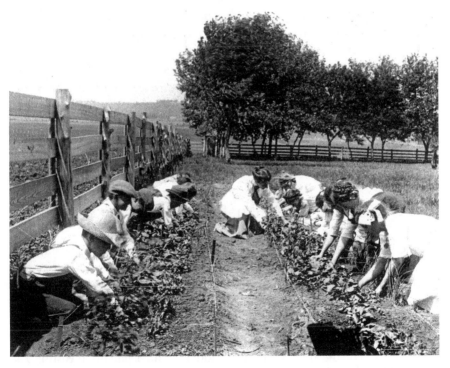

Jessie Field Shambaugh guided the formation of today's 4-H clubs during her tenure as an Iowa country school teacher. In the spring of 1901, "Miss Jessie's" students at the Goldenrod School near Clarinda planted and tended a garden in the schoolyard. On alternate days after school, Miss Jessie met with the older boys to study corn production and met with the girls to discuss the art and science of homemaking. *Courtesy of Iowa Digital Library, University of Iowa.*

By developing the Boys' Corn Club and the Girls' Home Club, Miss Jessie created the forerunner of 4-H and became the first female ag teacher in the nation. Her knowledge of agriculture was extensive, as her father had encouraged her to learn about farming methods from the time she was a young girl. As early as age twelve, Miss Jessie attended local Farmers' Institute meetings with her father and listened to presentations from ag leaders like "Uncle Henry" Wallace, who edited *Wallaces Farmer*.

Inspired by these ideas, Miss Jessie promoted hands-on, practical learning. She pioneered a powerful educational concept to help young people learn "to make the best better." By age twenty-four, Miss Jessie had been elected superintendent of schools for Page County. She later became one of the first female county superintendents in Iowa.

Starting in 1906, Miss Jessie enlisted the assistance of the 130 one-room country schools in Page County to form boys' and girls' clubs. Miss Jessie encouraged the young people to participate in judging contests. She believed that friendly competition inspired students to excel. At the Junior Exhibits held at the Farmers' Institute in Clarinda, entry classes for students included "Best 10 Ears of Yellow Dent Corn," "Best Device Made by a Boy for Use on the Farm" and "Best 10 Ears of Seed Corn Selected by a Girl."

The goal was to "make the country life as rewarding as it might be in any other walk of life," Miss Jessie noted in the book *The Very Beginnings*. "My mother always wanted to help the farm boys and girls," said Miss Jessie's daughter, Ruth Watkins of Clarinda, when I interviewed her in 2002. "She had great idealism and was able to carry it through to reality."

COOKING WITH THE RADIO HOMEMAKERS

Miss Jessie was the first of many innovative farm women from southwest Iowa who would transform Iowa's culinary and cultural history. For sixty-five years, a number of farm wives in the area (including Leanna Field Driftmier, a sister of Henry and Jessie Field) became popular "radio homemakers" who delighted audiences with their down-home, daily broadcasts.

The radio homemakers got their start when Henry Field recruited family members to go on the air on his radio station. Leanna began broadcasting *The Mother's Hour*, which became *Kitchen Klatter*. Without any broadcast training, Leanna sat down at the microphone and just started talking about her home, family, recipes, household tips, advice for child rearing and whatever news seemed worth sharing during the afternoon show.

Jessie Young, a radio homemaker, is shown here broadcasting from the kitchen of her home in Shenandoah in the 1950s. *Courtesy of Iowa Digital Library, University of Iowa.*

In 1930, Leanna broke her back in a car accident but wanted to continue her show despite her injuries. Radio equipment was brought to her home, and she broadcast from her bed and, later, from her kitchen table. The show became so popular among listeners that it was eventually was broadcast in six midwestern states.

As the radio homemakers' concept gained momentum, local farm women like Evelyn Birkby began broadcasting from their kitchens in the 1950s. In her show *Down a Country Lane* on KMA radio, Birkby would discuss her family and share snippets from her daily life, as well as offer suggestions for making the home a more pleasant place to live. Birkby called this phenomenon "neighboring on the air," and it met a vital need when farm life could often be isolating.

Fans would follow the doings of their favorite radio homemakers for years, tuning in each day the same way they'd listen to episodes of soap operas. Recipes figured prominently in the broadcasts, with old-fashioned, midwestern fare focused on meat and potatoes, hearty casseroles, cakes, pies, cookies and more.

As the radio homemakers' concept gained momentum in southwest Iowa, local farm women like Evelyn Birkby began broadcasting from their kitchens in the 1950s. In her show *Down a Country Lane* on KMA Radio, Birkby would discuss her family and share snippets from her daily life, as well as offer suggestions for making the home a more pleasant place to live. *Courtesy of Iowa Digital Library, University of Iowa.*

Through the years, a line of Kitchen Klatter products (including food flavorings, bleach and more) was developed and promoted over the radio by broadcasters like Leanna Driftmier. In addition, a monthly *Kitchen Klatter* magazine was circulated to thousands of midwestern readers, who enjoyed the articles, letters and recipes like Company Ham and Potatoes, Emerald Mint Sauce (made from Kitchen Klatter Mint Flavoring), Mary's Pineapple Pie and Grandma's Oatmeal Cookies. The Kitchen Klatter enterprise and the radio homemakers endured for a number of years, with some of the broadcasts lasting until the 1990s. (While the radio homemakers' era ended, a similar tradition lives on at *The Open Line*, a live, local recipe show that has been broadcast by 600 WMT radio in Cedar Rapids since the 1960s. Recipes featured on the show, from tapioca pudding to sugar cookies and more, can be found on WMT's website.)

HOOSIER CABINETS, JELL-O AND THE MODERN KITCHEN

Nearly a century ago, radios were one of the few amenities available to Iowa farm families. While farm kitchens were starting to modernize by the post–World War II era, many Iowa home cooks weren't too far removed from the kitchen technology of an earlier era, including the Hoosier-style cabinet. This freestanding kitchen workhorse was popular from the late 1890s into the first half of the twentieth century. Outfitted with metal-lined drawers (to store baked goods and keep them fresh), cupboards, a rack for pot lids, a built-in flour sifter, a spice rack and more, the wooden cabinet also included a tabletop surface (often covered in porcelain or zinc) that slid out to provide more work surface for rolling out pie crusts and managing other food preparation tasks.

The popularity of the Hoosier cabinet waned by the mid-twentieth century, as built-in kitchen cabinets became common. Still, vintage Hoosier-style cabinets (which sometimes turn up in antique stores and on eBay) remain functional today and work especially well in homes with small kitchens that are short on storage.

Hoosier-style cabinets also hearken back to an era when Iowa farm kitchens were typically outfitted with cookstoves fueled by corncobs and wood. The cookstove was the heart of the farm kitchen in Grant Wood's 1934 painting *Dinner for Threshers*, which offered a nostalgic look at Wood's memories of growing up on an eastern Iowa farm in the 1890s. The picture

Freestanding Hoosier-style cabinets were popular in Iowa kitchens from the late 1890s into the first half of the twentieth century. Outfitted with metal-lined drawers (to store baked goods and keep them fresh), cupboards, a rack for pot lids, a built-in flour sifter, a spice rack and more, the wooden cabinets also included a tabletop surface (often covered in porcelain or zinc) that slid out to provide more work surface for rolling out pie crusts and managing other food preparation tasks. *Author's collection.*

depicts a group of sunburned, hardworking farm men clad in denim overalls who had been threshing in the fields on a hot summer day. The painting shows how men would wash at a basin on the front porch before gathering around the kitchen table to fill their plates as the women served heaping bowls of mashed potatoes and other hearty fare.

There were no electric appliances in the kitchen depicted in *Dinner for Threshers*. Although electricity had come to Iowa's small towns and cities by the turn of the twentieth century (or soon thereafter), eliminating the need for old-fashioned iceboxes with ice cut from local rivers or lakes, electricity would not arrive on many Iowa farms until the 1930s or later. While the federal government created the Rural Electric Administration (REA) in 1935 to bring electricity to rural areas, the arrival of World War II delayed the electrification of a number of Iowa farms until the mid- to late 1940s.

When the lights did come on, however, some of the first appliances farm wives couldn't wait to buy included electric washing machines and refrigerators. Perhaps this pent-up demand for the miracle of electric refrigeration unleashed Iowa's love affair with Jell-O gelatin, which has endured for generations. While many Americans associate Jell-O with

While Jell-O sales began slipping nationwide in the 1960s and continued this downward trend for a number of years, Iowans' love for Jell-O never waned. In 1999, a national survey showed that Des Moines led the nation in per capita Jell-O gelatin consumption. Creations like this layered Rainbow Jell-O salad can still found at many church suppers and other gatherings in Iowa. *Author's collection.*

hospital food, Iowans have made it a staple of countless salads and desserts that turn up at picnics, church suppers, family meals and other gatherings. During a 2013 appearance in Ames, Iowa native and best-selling author Bill Bryson shared his own list of "You know you're from Iowa if…," which included, "…your mom knows at least 147 ways of making Jell-O."

Jell-O, which has been jokingly called the "State Fruit of Iowa," manifests itself in many ways, from jiggly little squares to a variety of colorful salads filled with fruit cocktail, applesauce, shredded carrots, pineapple, orange slices, apple chunks, nuts, cottage cheese, miniature marshmallows, celery chunks, whipped topping and more. From simple desserts to fussy, structured salads, Jell-O plays a key role in everyday foods throughout Iowa.

While Jell-O sales began slipping nationwide in the 1960s and continued this downward trend for a number of years, Iowans' love for Jell-O never waned. In 1999, a national survey showed that Des Moines led the nation in per capita Jell-O gelatin consumption, beating out Salt Lake City, Utah.

In many Iowa communities, Jell-O isn't an outdated dish past its prime. It's a popular tradition that can start a great debate about whether the Jello-inspired food in question is a salad or a dessert. While these Strawberry Pretzel Squares would qualify as dessert in most places, many Iowans have grown up calling this "Strawberry Pretzel Salad." Whatever you call it, it's tasty.

Strawberry Pretzel Squares

2 cups crushed pretzels
¾ cup butter, melted
3 tablespoons sugar

Filling:
2 cups whipped topping
1 package (8 ounces) cream cheese, softened
1 cup sugar

Topping:
2 packages (3 ounces each) strawberry gelatin
2 cups boiling water
2 packages (16 ounces each) frozen sweetened sliced strawberries, thawed

In a bowl, combine the pretzels, butter and sugar. Press into an ungreased 13- by 9-inch baking dish. Bake at 350 degrees for 10 minutes. Cool on a wire rack.

For filling, in a small bowl beat whipped topping, cream cheese and sugar until smooth. Spread over pretzel crust. Refrigerate until chilled.

For topping, dissolve gelatin in boiling water in a large bowl. Stir in strawberries with syrup; chill until partially set. Carefully spoon over filling. Chill for 4–6 hours or until firm; cut into squares. Serve with whipped topping if desired. Yield: 12–16 servings.

Lessons from a Farm Wife

While Iowans may be Jell-O connoisseurs, the best cooks' repertoire extends far beyond gelatin, especially among farm cooks. While some of these home cooks were born into the farming lifestyle, others came to it by marriage.

Consider Alice Ann (Runquist) Dial, a town girl who grew up helping her father in his Lohrville drugstore and studied home economics at Iowa State. She had to learn a thing or two about farm-style cooking after she married her husband, Gerald, in June 1945. "One day I made a beautiful cheese soufflé," recalled Alice Ann, who lived with Gerald on a farm northwest of Lake City for more than sixty years. "Gerald was not impressed, though, and informed me that this wasn't the way to cook for a farmer."

Alice Ann also caused a stir in the couple's rural neighborhood when she began taking morning and afternoon coffee and treats to Gerald—a routine that wasn't the norm in the area. "My father's family is Swedish, and his relatives farmed in Kansas," Alice Ann explained to me one fall day when I stopped by her farm kitchen in 2007. "My aunts always took morning and afternoon coffee to my uncles when they worked in the fields, so I thought that's what farm wives did. Besides, I got lonesome and was glad to see Gerald."

When she was well into her eighties, Alice Ann continued to deliver special lunches to Gerald and their son, Dwight, especially during the busy harvest season. She still used the same cast-iron Dutch oven that she relied on for more than sixty years to make roast beef and other dinnertime favorites. Armed with portable coolers and cardboard boxes, Alice Ann would load

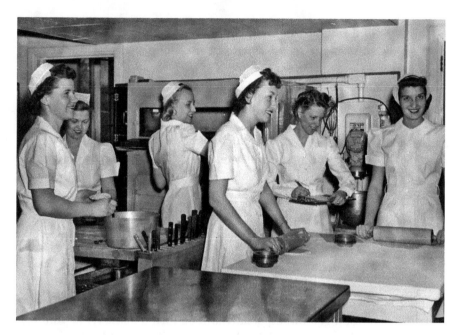

In the early 1920s, students from Iowa State College's (now Iowa State University) Department of Hotel, Restaurant and Institution Management began selling cherry pies at a bake sale each February. The cherry filling was selected to commemorate George Washington's birthday. The first cherry pies were sold with ham sandwiches and coffee, and the pie was offered à la mode. When VEISHEA debuted in 1922 to showcase all the colleges at Iowa State, the cherry pie sale became a popular tradition that endured until VEISHEA was canceled permanently in 2014. *Courtesy of Iowa State University.*

the trunk of her car at noon with a main dish (which often included fried chicken), salads, apples, jars of milk, cans of soda pop and dessert (which sometimes included her famous lemon pie) and delivered the spread right to the field. Call it al fresco dining, Iowa style.

Alice Ann freely shared her recipes, as well as a lifetime of cooking tips, to help others save time and improve their results in the kitchen. She taught me not to be afraid to use plenty of onions in my cooking to add extra flavor. "They are inexpensive and also make good gravy," she noted. Alice Ann was also an expert lemon meringue pie baker. When making meringue for a pie, she recommended bringing the eggs to room temperature before mixing to ensure the highest peaks. Then beat the egg whites until they display a satin-like appearance. They should not look glossy. When you add the sugar to the meringue, let it trickle in, and then beat the mixture hard. To keep meringue from pulling away from the edge of a pie, first spoon the mixture along the rim and seal the edges. Then pile the rest of the meringue in the middle of the pie.

Alice Ann's Lemon Meringue Pie

For the Filling
2 cups sugar
4 egg yolks
2 cups water
½ cup cornstarch
dash of salt
8 tablespoons fresh lemon juice
2 tablespoons butter

For the Meringue
4 egg whites
8 tablespoons sugar
¼ teaspoon cream of tartar

To mix the pie filling: Blend sugar, egg yolks, water, cornstarch and salt. Cook until the mixture thickens and bubbles up. Remove from heat and add lemon juice and butter. Pour the filling in a prebaked pie shell made from Alice Ann's all-purpose pastry mix (see recipe following) and cover immediately with meringue.

To make the meringue, beat the eggs whites until foamy. Add sugar and cream of tartar. Beat slowly until peaks form. Spread on pie, and bake the pie for 20 to 25 minutes at 325 degrees.

Alice Ann's All-Purpose Pastry Mix

7 cups flour
4 teaspoons salt
2 cups lard

Combine all ingredients together to create a crumbled consistency, but make sure the mix doesn't clump together. Store mixture in a covered container in the refrigerator.

For a single crust:
1½ cups all-purpose pastry mix
3 tablespoons ice-cold water

For a double crust:
3 cups all-purpose pastry mix
5 tablespoons ice-cold water

Combine the all-purpose pastry mix and ice water until the mixture leaves the sides of the bowl. Then roll out the dough. If you're making a pie shell for a lemon meringue pie, place the crust in a pie plate and prick the dough with a fork on the bottom and sides before baking the crust at 350 degrees for 10 to 12 minutes.

Viola Township Homemakers Club Celebrates More than Sixty Years of Friendship

When farm wives like Alice Ann Dial were busy raising their families, they also enjoyed socializing with other farm women. In many parts of rural Iowa, ladies banded together to form local clubs that met monthly in the members' homes.

Women in small towns had groups like the Shakespeare Club and Federated Arts, while farm women came together in groups like the Friendly Club and the Viola Township Homemakers Club. While many of these clubs disbanded by the 1980s or early 1990s as members passed away and retired farmers and their wives moved to town, some groups continue. Such is the case with the Viola Township Homemakers Club, which was formed by farm wives in Audubon County's Viola Township following World War II.

A dozen members of the Viola Township Homemakers Club met in December 2014 in Carroll to celebrate the group's Christmas party and invited me to join them as they reminisced about favorite memories. "I've made so many incredible friends and continue to have a lot of fun with the group," said Doris Meshek, who lives on a farm in Audubon County.

For young mothers raising children on the farm in the mid-twentieth century, opportunities for socialization were limited mainly to Saturday shopping trips to town and Sunday morning church services. Audubon County women who wanted more took matters into their own hands by joining the Viola Township Homemakers Club, which usually had eighteen to twenty members. "We were all from the farm and shared a lot of common concerns," said Doris, who enjoyed forming stronger friendships with her neighbors and watching one another's children grow up. "We needed each other."

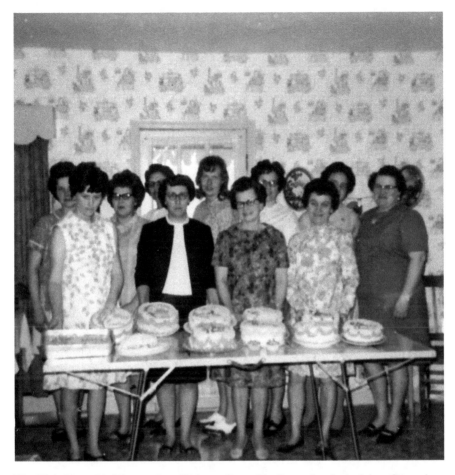

The Viola Township Homemakers Club was formed by farm wives in Audubon County's Viola Township following World War II. For years, the club met in members' farm homes once a month. Each afternoon meeting included an educational program (such as cake decorating, shown here), followed by homemade refreshments provided by the hostess. *Courtesy of Viola Township Homemakers Club.*

The structure of the Viola Township Homemakers Club has always been informal, with no official charters, no dues and no officers. For years, the club met in members' farm homes once a month on a Tuesday or Wednesday afternoon at 1:00 p.m. Meetings were scheduled from September through April. "Depending on how many of us had little ones at home, we might have more children at the meetings than mothers," said Doris, who noted that club members' families ranged from two to nine children.

Each afternoon meeting included an educational program (such as cake decorating) or a craft project, followed by homemade refreshments provided by the hostess. When the afternoon's activities were complete, club members drew names to see who would host the next month's meeting (and give their husbands ample warning not to spread manure in any nearby fields on club day).

While club members decided to stop meeting in one another's homes about five years ago, the ladies still meet the second Wednesday of each month from March through December at tearooms, wineries, museums and other destinations in the area. The Viola Township Homemakers Club continues to fill a need, even though many of the farms where members once lived are now gone. "These ladies have provided a positive, supportive environment for years," said club member Carol Meiners of rural Coon Rapids. "Today, this is called therapy."

Chapter 4

MEAT GALORE

With its farm roots and agricultural heritage, Iowa is a meat-and-potatoes kind of place. Thanks to its strong livestock industry, Iowans are connoisseurs of the world's best meat, including beef, pork and turkey.

Beef is big business in Iowa, which is among the top ten beef-producing states in America. Beef cattle are raised in all of Iowa's ninety-nine counties and supply a safe, consistent source of nutritious, flavorful beef for steaks, hamburgers and more. There are nearly twenty thousand Iowa farms with beef cows, and Iowa has more 5,300 feedlots, according to the 2012 census.

Just how many beef cows are there in Iowa? All cattle and calves in Iowa totaled 3.95 million head in January 2016, according to the U.S. Department of Agriculture's National Agricultural Statistics Service. (Compare this with the population of Iowa, which totaled more than 3.1 million people in 2014.) Much of the corn raised in Iowa helps produce the state's delicious corn-fed beef. Iowa's cattle industry helps Iowa's grain farmers by using 148 million bushels of corn as cattle feed, according to the Iowa Beef Industry Council.

In 2013, Iowa's cattle industry contributed in excess of $6 billion in business activity to Iowa's economy, along with thousands of jobs. The beef industry is also the source for some of the tastiest food traditions in Iowa, from the Best Burger in Iowa contest to the state's legendary steakhouses.

Get Your Greek on at the Northwestern Steakhouse

When in the north Iowa community of Mason City, do as the Greeks do, especially if you're headed to the famous Northwestern Steakhouse. This casual, "come as you are" restaurant has been described as a steakhouse that hasn't fully moved into the twenty-first century, and that's just the way people like it. "We have customers whose families have come here for five generations, and we get visitors from all over the world," said Ann Papouchis, who has run the Northwestern Steakhouse with her husband, Bill, for nearly thirty years.

The Northwestern Steakhouse features aged, USDA top choice Iowa beef cooked in extra virgin olive oil, butter and a special blend of Greek seasonings that make every bite of steak melt in your mouth, especially the nine-ounce fillet. Many of these steaks are still cut by hand.

"Never stray, order the fillet," advised Mindy Anderson, a Greene, Iowa native whose family has been coming to the Northwestern Steakhouse for nearly sixty years. While Anderson and her husband, Paul, now live in Minneapolis, Minnesota, they still make the more than two-hour trip to Mason City about once a month to enjoy the fine dining at the Northwestern Steakhouse. "It's a family tradition," added Mindy, whose parents patronized the Northwestern Steakhouse for years, making it their go-to spot to celebrate birthdays, anniversaries and other special occasions.

"The food is phenomenal," Paul Anderson told me on a recent Saturday evening when every booth and table in the dining room was packed. "You've never had a steak like this." He wasn't kidding. The Northwestern Steakhouse has been serving up a unique, savory taste of Iowa since 1920. If you're looking for a slick, urban steakhouse with inflated prices, this isn't it. Located on the north edge of Mason City at 304 Sixteenth Street Northwest near middle-class neighborhoods, baseball fields and cement plants, this unassuming, locally owned and operated restaurant has been serving working men and their families for generations.

"This area was a melting pot a century ago," Ann Papouchis said. "There was a cement plant in this area, along with a sugar-beet processing plant, and our family's restaurant started as a little café that fed migrant workers from the cement plants." In the early 1900s, Mason City had become a significant manufacturing and retail area in Iowa. The city's lime, brick and tile businesses developed rapidly with the opening of the Northwestern State Portland Cement Plant in 1906, followed by the Lehigh Portland Cement

Company in 1910. As these industries flourished, Mason City's population steadily increased as many immigrants from southern and eastern Europe came to the area to find work. By 1912, Mason City was producing more brick, tile and Portland cement than any city in the world, according Visit Mason City Iowa, the local convention and visitors' bureau.

While the forerunner of the Northwestern Steakhouse opened in 1920, owners Pete Maduras and Tony Papouchis moved the business (known as Pete's Place in those days) in 1932 to a little building on North Federal Avenue in Mason City. T-bone steaks cost a whopping twenty-five cents, and liquor was bootlegged out of the basement. In 1954, the pair moved Pete's Place to its present location on Sixteenth Street Northwest. Pete and Tony continued their partnership, with Pete as the waiter/businessman and Tony as the cook/gardener. The men had a large garden with more than two hundred tomato plants, fifty green pepper plants and many other vegetables.

By 1965, Pete wanted to retire and sold the business to Tony. It was at that time that the name changed to the Northwestern Steakhouse. Tony continued to plant his garden every year, harvesting fresh vegetables each summer to use in the restaurant. All of his customers looked forward to Tony's fresh "salatas," along with his special Greek menu on Sundays.

Tony was still cooking at his beloved Northwestern Steakhouse at age ninety-six. In an interview with the local newspaper, he said he continued to work because he liked it. "Better to be working," emphasized Tony, who worked 365 days a year and passed away at age ninety-eight.

Today, the Northwestern Steakhouse is operated by Tony's son, Bill, and Bill's wife, Ann, who keep a portrait of Tony hanging on the wall behind the cash register. Like it has for decades, the brick restaurant retains a relaxed atmosphere complete with wooden booths with dark-colored seats, walls adorned with images of Charlie Chaplin and other Hollywood legends and the soft, golden glow of lamps hanging over each booth.

The straightforward menu at the Northwestern Steakhouse showcases the finest beef in Iowa, all prepared in olive oil and doused with an incredible blend of Greek seasonings and top-secret ingredients. Guests can choose from steaks including a porterhouse T-bone, New York cut, the Northwestern Steakhouse's signature fillet, ladies' fillet, rib-eye or top sirloin, with dinner prices ranging from $28.95 to $31.95 as of February 2016. As the menu notes, the restaurant is "not responsible for steaks ordered medium well or well done. Please order accordingly."

Meals are served with an array of options, including spaghetti topped with olive oil, Greek seasonings and parmesan cheese, along with Greek

salads with feta cheese, black olives, mild peppers, olive oil dressing and Greek seasonings. Guests can enjoy their steak (or other entrée) with wine, liquor or beer. Things were different before Iowa legalized the sale of liquor by the drink in the early 1960s for on-premises consumption. Before that, patrons would bring in their own alcohol, typically hard liquor, and the Northwestern Steakhouse would supply 7 Up as the mixer.

Beyond that, however, few things have changed through the years at the Northwestern Steakhouse. The restaurant is still known for its friendly atmosphere and melt-in-your-mouth steaks. Keeping the place small is much more of an attraction for the Northwestern Steakhouse's customers, said Ann, who knows many of her customers by name and ensures that the restaurant provides a welcoming, relaxing environment.

Perhaps no one knows this better than the Northwestern Steakhouse's longtime customers, like Neil Pogeler from Florida, whose story is recorded on the "Memories" section of the restaurant's website. "I remember my dad bragging about this place to everyone he met for years after he left Mason City. Now that he's gone, it's my turn to brag about it," said the Mason City native, who has been a customer of the Northwestern Steakhouse for more than fifty years. "I can even tell you the taste is exactly the same as it was back then. (You never forget a certain taste or smell.) I enjoyed seeing the old building again and knowing that someone has kept the experience exactly as it was, and following the same ways of cooking that made the Northwestern famous in the first place. You just don't see that happen much anymore. Kudos to you, and may your restaurant live on forever!"

ARCHIE'S WAESIDE EARNS JAMES BEARD HONORS

Another classic north Iowa steakhouse has also attracted a legion of loyal customers for generations. For nearly seventy years, Archie's Waeside in the northwest Iowa town of LeMars has featured dry-aged, hand-cut steaks, cooked to perfection.

Dry-aging the steaks makes the meat tender and the flavor more intense. Archie's steaks have won rave reviews from Rachael Ray to Roadfood's Jane and Michael Stern. The restaurant has been featured in the *New York Times* and won the prestigious James Beard Foundation Award for Excellence in 2015. "Set in what was once a roadhouse bar, Archie's Waeside is a citadel of American beef cookery," noted the James Beard Foundation. "Seated in

commodious booths, in a dining room accented with Christmas tchotchkes, regulars drink perfect Manhattans, snack on a well-curated relish tray, and eat porterhouses, dry-aged in-house for four weeks."

If you're in the area, don't bother trying anyplace else, customers say. The service is impeccable, along with small-town prices, and Archie's steaks rival anything you will get anywhere else in the country. It's all about tradition at Archie's. And tradition, like steak or a fine wine, gets better with age, said Bob Rand, who's the third generation of his family to own the restaurant.

Established in 1949 by Bob's grandfather, the late Archie Jackson, Archie's Waeside reflects the American dream. After escaping from Russia during the 1917 Bolshevik Revolution that led to the rise of the Soviet Union, Archie came to America and made his way to the Midwest.

He learned the art of cutting and dry-aging beef in the meatpacking houses of Sioux City in the 1930s and Los Angeles in the 1940s. "He knew you needed great beef to have a great meal," Bob said. The techniques he learned were used to create a distinctive flavor of steak that he featured on the original menu at Archie's, which consisted of a sirloin steak, pan-fried chicken, deep-fried shrimp and chicken livers and gizzards. Aided by his daughter, Valerie (Val) Rand, Archie's business grew. The family expanded the restaurant in 1957 and again in 1963 to increase the size of the kitchen, coolers and dining area.

After Archie's death, Val continued to grow the business. She added the current bar and lounge area (which retains its late 1970s vibe) and also expanded the menu. Val instilled in her five children a strong work ethic and taught them the restaurant business from a young age. Her youngest child, Bob, embraced this legacy and took over the ownership of Archie's Waeside in 1995, following his mother's retirement.

Aided by his sister, Lorrie Luense, Bob has continued to grow the business, most notably with the addition of a large, diverse wine selection. Today, Archie's menu contains twelve different cuts of meats, as well as a large selection of fresh seafood. Archie's menu is loaded with steaks, including top sirloin, rib-eye, porterhouse and a peppered New York cut.

Insiders know that one of Archie's signature steaks isn't on the menu. If you say you want the "Benny Weiker," you'll be served a delicious, dry-aged beef tenderloin cut. It all goes back to a beef salesman from the Sioux City stockyards in the 1950s and 1960s named Benny Weiker, who thought the beef in northwest Iowa was the greatest in the world. The claim was that all the beef Weiker bought went to posh restaurants in New York and the like.

For nearly seventy years, Archie's Waeside in LeMars has featured dry-aged, hand-cut steaks, cooked to perfection. Three generations of the restaurant are shown here around 1963 or 1964, including founder Archie Jackson (who opened the restaurant in 1949); his daughter, Valerie; and her son Bob, who now owns the restaurant, which won the prestigious 2015 James Beard Foundation Award for Excellence. *Courtesy of Archie's Waeside.*

"Benny was legendary in the yards," said Bob, who has been Archie's principal meat cutter since he was fourteen years old. Grandpa Archie decided to name a steak after the man. Bob, who remembers getting out of school on Monday afternoons to go with his grandpa to the stockyards to select meat, agrees with Weiker's philosophy. "The greatest beef in the world is raised right here in northwest Iowa and northeast Nebraska. We're fortunate enough to be able to buy that every day and dry age it and sell it. That's our secret."

While Iowans have appreciated Archie's for decades, food critics from coast to coast are also taking note. "The Archie's experience has all the marks of the best Iowa dining," reported the *New York Times* in a January 15, 2016, article titled "Another Reason to Caucus in Iowa: The Restaurants." "It may take some extra effort, and the setting will probably not be fancy, but the food is often memorable."

The memorable food is what motivates customers from Omaha, Nebraska, to Sioux Falls, South Dakota, and beyond to dine at Archie's. For them, Archie's is a destination. Yet many of Archie's die-hard customers are locals who've been coming in for years. Each customer can expect a deliberately old-school steakhouse meal that begins with a relish tray and continues on to salads with homemade dressings. "It would be easier to serve premade foods, but when you have a hand in making it, the food just tastes better," Bob said.

The success of the family business started by Archie Jackson in 1949 is due in large part to the traditions that have been preserved and passed down from generation to generation, Bob noted. This also extends to the many Iowa families who have made dining at Archie's a favorite tradition of their own.

BURGER BRAGGING RIGHTS

While Iowans take their steak seriously, they also love to honor the "Best Burger" in Iowa. Each year since 2010, Iowa's cattle producers have asked their fellow Iowans to help find Iowa's Best Burger, whether it's gourmet or down-home.

The popular contest, which is sponsored by the Iowa Beef Industry Council and Iowa Cattlemen's Association, attracts thousands of nominations each year. In 2015, more than four thousand nominations for 286 restaurants were received in the contest. To qualify to be named

Iowa's Best Burger, the burger must be a 100 percent beef burger and served on a bun or bread product. The top ten restaurants with the most votes are eligible for the title. An anonymous panel of judges visits the top ten restaurants to judge the burgers on appearance, taste and proper cooking temperature (160 degrees Fahrenheit) to determine the winner, which is showcased during May Beef Month.

Winners have come from all across the state, including the Cider House in Fairfield (2015), Brick City Grill in Ames (2014), 61 Chop House Grille in Mediapolis (2013), Coon Bowl III in Coon Rapids (2012), the Rusty Duck in Dexter (2011) and the Sac County Cattle Company in Sac City (2010).

When I visited the Sac County Cattle Company following its big award, I noticed the sign reading, "Good cooks never lack friends" just outside the entrance to the kitchen. It's certainly true at this popular Sac City restaurant, where the mushroom Swiss burger was named the 2010 Best Burger in Iowa. The half-pound mushroom Swiss burger is a 100 percent ground beef patty loaded with sautéed mushrooms and topped with melted Swiss cheese on a toasted bun. "Within a few days after we won the Best Burger contest, we sold about four hundred burgers," said owner Doug Kruchten, a Fonda, Iowa, native who grew up on a farm and is well versed in Iowa's beef industry.

Doug raised purebred Charolais cattle in Sac County and later owned a cattle herd in Missouri before turning his attention to the restaurant business. He opened the Sac County Cattle Company in May 2007 in a former clothing store along old Highway 20 in Sac City. He didn't advertise, but word of mouth grew the business from about 25 customers on the first Tuesday night the restaurant was open to 285 customers by Friday night of that same week. The business just took off from there. "We're basically a red meat and potatoes place that serves quality beef," Doug told me. "I believe that keeping things simple is the key to our success."

Sometimes the Best Burger in Iowa isn't found in a restaurant. Consider the Coon Bowl III in Coon Rapids, which won the award in 2012. "One Saturday night after we won the Best Burger in Iowa contest, we had so many customers that you couldn't have stuck a shoe in here," said Cindy Heydon, co-manager of the Coon Bowl III, who visited with me when I stopped by in May 2012.

It's hard to forget the taste of classic Iowa hamburgers, which are served everywhere from bowling alleys to local cafés to the finest white-tablecloth establishments. "The burgers here are big and juicy, and you get them for a fair price," said Dwight Olson of Reading, Michigan, who grew up on a

farm southwest of Coon Rapids and was back in the area to visit family the day I stopped by the Coon Bowl III. "They've always had good food here."

Olson, who used to set pins at the Coon Rapids bowling alley for a penny apiece when he was a boy, is glad that Coon Rapids still has a bowling alley and diner. "It's good to see these little towns do well."

The Coon Bowl III offers a unique setting to serve up not only Iowa's best burger but also a slice of small-town Americana. The bowling alley, which has been in Coon Rapids for nearly seventy years, is housed in a former farm implement dealership. Local farmers are some of the most loyal customers, Heydon said. "We get a lot of carry-outs, especially at planting and harvest."

When I visited the bowling alley, its famous burgers were made with an 80/20 blend of ground chuck supplied by the Arcadia Locker. Dan George, who handled much of the grilling at the Coon Bowl III, didn't add any seasoning unless a customer requested it. It took him about fifteen minutes to grill each half-pound burger. Customers were in charge of asking for any extras, whether that was "running the burger through a garden" with lettuce, pickles, onions and tomatoes, or requesting cheese or bacon.

Darlyne Jorgensen of Guthrie Center told me that she and her husband, Al, decided to head over to the Coon Bowl III after they heard about the Best Burger in Iowa. "The burgers here are darn good, and they're worth the trip," she said.

The 2015 winner of the Best Burger in Iowa contest took Iowa beef to a whole new level. The Cider House in the southeast Iowa town of Fairfield buys locally grown cattle and uses all the meat cuts from them in the grind for its 6.5-ounce hamburger patties. Where others might see chuck, rib, sirloin and round cuts from the beef animal, the owners of the Cider House see a very tasty hamburger.

Judges found the beefy flavor at the Cider House to be the best. In fact, its hamburger is so good that it inspired one of the owners who was formerly a vegetarian to give meat another try. It all started when the four owners of the Cider House—Clint Stephenson, Hopi James, Cole Fishback and Annalisa Thompson—first thought about their pub-styled restaurant as a way to showcase the hard apple cider they were producing. Many of those discussions occurred while grilling hamburgers at one of their homes.

Stephenson, a onetime vegetarian, declared in 2013 that the group should open a burger shack to showcase their cider. By October 2014, the team had completely gutted and renovated a former barbershop to make their dream come true. Stephenson's return to eating beef came when he came back to

Fairfield and reconnected with his friend Tony Adrian. The two had known each other since fourth grade. Adrian convinced his friend to give the beef from his farm a try. "It was really great," Stephenson said.

The Cider House exclusively features beef from Adrian Family Farms. The cattle are raised like so many others in Iowa: pasture-grazed and corn-finished, cared for with compassion and treated humanely. The Adrians tell their beef story with four- by six-inch cards placed at the tables around the cozy restaurant. "Tony pays attention to the whole growth cycle, and you can tell that in the way the meat tastes," Fishback said. Cider House cooks use a flat-top grill to quickly sear in the juices, "because that's where the flavor is." The hamburgers they serve are designed to showcase the excellent flavor of Iowa beef, and all come with a choice of homemade potato salad or triple-cooked fries, as well as refrigerator pickles.

Stephenson noted that all four owners of the Cider House appreciate the exceptional food ingredients available in Iowa. "We've all traveled around the world, but it's in Iowa you'll find the best foods. It's an amazing state."

This well-kept secret isn't so secret anymore. When members of the national media descend on Iowa every four years to follow presidential candidates and report on the Iowa Caucus, many head to Zombie Burger in Des Moines's historic East Village. Famous for inventive flavor combos in a "post-apocalyptic chic" setting, Zombie Burger + Drink Lab serves fast food with a culinary edge, promising guests an escape from boring food and drinks. Burgers as diverse as Dead Moines (with smoked gouda, prosciutto, ham and truffle mayo) and the East Village of the Damned (with a breaded mushroom plus cheese croquette, American cheese, lettuce, tomato, onion and mayo) have helped Zombie Burger (which also has a location in the Jordan Creek Town Center in West Des Moines) make the top ten finalist list multiple times for the Best Burger in Iowa.

In 2016, Zombie Burger offered a variety of Iowa Caucus specials. They ranged from the Greatest, Most Delicious Burger in the History of the World (think Donald Trump), with braised short rib, demi and truffle mayo flopped over Parmesan crisp, to the #FeeltheBern (inspired by Bernie Sanders), with aged cheddar, ghost pepper matzah ball and pastrami-pepper hash.

For Chef George Formaro, a Des Moines native whose name is as famous as his Des Moines restaurants—including Zombie Burger, Centro and Django—creativity definitely makes Iowa a more interesting, and flavorful, place to live. While he's had requests from Los Angeles to Portland and beyond to create a Zombie Burger franchise, he's not ready to make this move. "I love Zombie Burger," he told a local television

reporter during a 2013 interview. "Right now, I like it being unique to the Des Moines area."

Northeast Iowa also has its own unique take on burgers and ground beef. In the Clayton County town of Gunder, the Irish Shanty is the home of the massive Gunderburger. The Gunderburger debuted in the late 1970s as way to put Gunder on the map. The first Gunderburgers were a smaller version of the huge ones served today. As the Gunderburger started growing in size in the 1990s, it also grew in notoriety. If you order one of these beefy behemoths, be prepared to share, unless you have an extremely hearty appetite.

Not in the mood for a burger? No problem. If you're near Gunder (or anywhere in the vicinity of this part of northeast Iowa), raw dawg might be more your style. As northeast Iowa's version of steak tartare, raw dawg is a favorite delicacy in the area. Made from lean, ground sirloin (uncooked, of course), raw dawg is seasoned with lots of pepper and some salt. The big debate often revolves around the crackers served with raw dawg. Some northeast Iowans prefer to eat their raw dawg with saltines, while others opt for buttery club crackers. Not only do people make their own raw dawg at home, but it can also be found in certain northeast Iowa stores, usually from Thanksgiving through New Year's. It also makes an appearance in time for Super Bowl parties. Raw dawg is typically sold by the pound right beside the ground beef. Northeast Iowa friends tell me that raw dawg can also be found most of the year at Bender's Foods in Guttenberg along the Mississippi River, which caters to the boating and fishing crowd.

Ground beef also turns up in a quirky recipe related to an Iowa native and Hollywood star. It's called John Wayne Casserole and takes its name from the famous movie star, who was born Marion Robert Morrison on May 26, 1907, in Winterset. "The Duke" starred in many popular western movies, and his legend lives on in the new multimillion-dollar John Wayne Birthplace museum, which opened in Winterset in 2015. While there are few facts and lots of conjecture about the history of the John Wayne Casserole, one thing is certain: it offers an authentic, memorable taste of America, just like the Duke himself.

John Wayne Casserole (Beef and Biscuit Casserole)

2 pounds ground beef
1 packet taco seasoning
¾ cup water
½ cup sour cream
½ cup light mayonnaise
1 cup cheddar cheese, shredded
1 onion, diced
2 cups biscuit mix
1 cup water
green bell pepper, diced
1 can diced tomatoes, drained
1 (4-ounce) can green chilies

Preheat oven to 325 degrees. Spray a 9- by 13-inch baking dish with nonstick cooking spray. Brown ground beef until no longer pink. Add taco seasoning and ¾ cup water and let simmer for 3 to 4 minutes. In a medium bowl, mix sour cream, mayonnaise, half of the cheese and half of the onion together and set aside. In another bowl, mix together biscuit mix and water to make a soft dough. Press dough into the bottom and half an inch up the sides of the greased pan. Sauté remaining onions and green peppers until barely tender.

On top of the biscuit, layer the remaining ingredients in this order: seasoned ground beef, diced tomatoes, green peppers and onions, green chilies, sour cream mixture and remaining cheddar cheese. Bake for 30 to 35 minutes or until edges are slightly browned.

Hog Heaven: Iowa Knows All Things Pork

While beef is big in Iowa, it's hard to think of Iowa without thinking of pork. After all, Iowa has long been the nation's top pork-producing state. With more than 21 million pigs across the state (according to December 2015 data from the USDA), there are about seven times more pigs than people in Iowa.

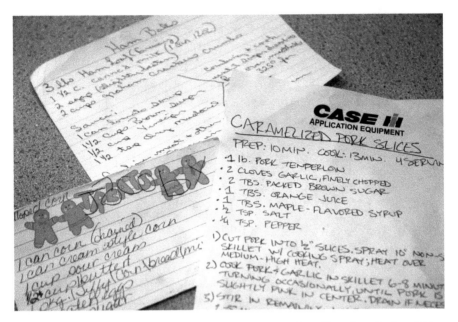

For decades, handwritten recipes like these were a key part of any Iowa farm kitchen. This tradition is changing as more cooks go online to find recipes. *Author's collection.*

Pigs and Iowa are a natural fit, as hogs are the single largest consumers of Iowa's abundant corn and soybeans, eating nearly one-third of Iowa's grain. While Iowa hogs provide the bacon, ham and other popular pork cuts that many Americans like to eat, Iowa pork is also exported around the globe. It's no wonder, since pork is the most widely consumed meat in the world, and Iowa pork is known for being a safe, nutritious product.

Pork can also be surprisingly lean. The National Pork Board (based in Clive, Iowa) promotes the Slim 7, the seven common cuts of pork that are, on average, 16 percent leaner than twenty years ago. Among the Slim 7 are pork tenderloin, which is as lean as a skinless chicken breast. It's also hard to beat pork's versatility, noted the National Pork Board, which promotes a "Pork Be Inspired" message.

Pork can be as down home as pork chops or as upscale as a creative chef's imagination can go. This culinary creativity is on display in Iowa each year when the Iowa Pork Producers Association hosts its popular Taste of Elegance competition. Since 1987, chefs across the state, from independent restaurants to country clubs, have entered their best original dishes for the chance to win top honors.

In 2005, I interviewed Chef Ephraim Malag, who was the executive chef at the Tournament Club of Iowa in Polk City. "I don't want to add lots of spices or gravy that hide the pork's flavor," said Ephraim, whose "Jasmine Tea Pork Chop Apanoose" won the People's Choice Award at the 2005 Taste of Elegance competition in Des Moines. "There's so much you can do with pork, and I like to offer pork in new, dynamic ways."

POLITICIANS AND PORK CHOPS ON A STICK

Pork doesn't just take center stage at the Taste of Elegance competition. Thousands of people flock to the famous Pork Tent at the Iowa State Fair in Des Moines each year to enjoy pork chops on a stick and more. The Pork Tent, where pork producers from across Iowa volunteer to grill the meat, has also become a premier photo opportunity for politicians of all types, including presidential hopefuls.

The Pork Tent has been a fixture since it opened at the Iowa State Fair in 1981, said Kelsey Sutter, marketing and program director for the Iowa Pork Producers Association. When I asked her to share some numbers from the Pork Tent, she explained it in terms of cooked totals during the eleven-day run of the fair:

- pork chop on a stick: 65,400
- grilled loin sandwiches: 6,195
- pork burgers: 6,250
- shredded BBQ sandwiches: 6,900
- Iowa chops: 11,150

Speaking of the Iowa chop, this delectable cut was introduced by the Iowa Pork Producers Association and the Iowa Development Commission in the early 1980s as a new pork cut that would appeal to consumers at the meat case and at restaurants. Its specifications are very simple: bone-in, thick-cut center loin chop cut one and one-fourth inches to one and one half inches thick.

The Search for Iowa's Best Tenderloin

Iowans love their pork big and bold, whether it's thick and juicy like an Iowa chop or thinner but as huge as a dinner plate like Iowa's famous breaded tenderloins. Sometimes called an "I state" phenomenon, breaded pork tenderloins tend to be found mainly in midwestern states like Iowa, Illinois and Indiana. Some attribute this to the region's strong German heritage (think schnitzel) and tradition of pork production.

Since 2003, the Iowa Pork Producers Association has hosted the Iowa's Best Tenderloin contest. While most of the winners have been breaded tenderloins, at least one winner was a grilled tenderloin. In 2014, the Iowa Pork Producers Association received more than 1,900 nominations from tenderloin fanatics.

After the Lucky Pig Pub & Grill in Ogden earned Iowa's Best Tenderloin honors in October 2014 (just in time for Pork Month), the prestigious award helped this central Iowa restaurant attract customers from almost every Iowa county and every state surrounding Iowa. Following the announcement, business was nonstop at the Lucky Pig, which is owned by Craig and Carol Christensen, who also farm and raise hogs near Ogden.

When the Lucky Pig earned top tenderloin honors, the restaurant sold about six hundred tenderloins in just one day, as I found out from Craig, who had to stop harvesting soybeans the October afternoon I stopped by so he could help seat guests and serve food in the packed dining room. This level of service—and exceptional food—has made the Lucky Pig a destination.

The Christensens purchased the restaurant in 2011 because it was dying, and they believed Ogden (population 2,044) needed a restaurant. "We wanted to make this a community gathering place that feels like family," said Craig, a fourth-generation Boone County farmer. "People in the community and local counties have really supported us."

Many keep coming back for the tenderloins, as well as the wide array of innovative pork sandwiches, main dishes and more. "As a pork producer, I've traveled the state, the country and the world eating great pork dishes, so my bar was set pretty high," said Craig, a past president of the National Pork Board. "I challenged our crew to develop something that was top notch."

The pork for the Lucky Pig's famous tenderloin sandwich is soaked in buttermilk for twelve to twenty-four hours to tenderize the meat and add flavor. Then each slice is hand pounded in-house and double coated in a batter and bread crumb mixture. It provides an ideal meat-to-bun ratio and

features a unique spice for a one-of-a-kind flavor profile, I found out from Greg Hager, who was cooking at the Lucky Pig when I stopped by.

Word spread quickly about the award-winning tenderloins. "We served some guests from Denver, Colorado, who were passing through Iowa, heard about our tenderloins on the radio and decided to stop in," Greg told me.

The Iowa's Best Tenderloin contest judges evaluate tenderloins on the quality of the pork, taste, physical characteristics and eating experience. "Ultimately, we're looking for a sandwich that showcases pork first and is complimented with a flavorful breading," said Chef Phil Carey, who helped judge the 2014 contest. "The final panel of judges didn't know that the owner of the Lucky Pig also raises pigs on a family farm, but it's really no surprise that someone who raises the product also knows how to properly prepare it."

Want to create your own version of a classic Iowa breaded pork tenderloin? Try this one from my friend Jenny Unternahrer from southeast Iowa, who writes the blog "In the Kitchen with Jenny."

BREADED PORK TENDERLOINS

1 cup flour (divided)
1 egg
½ cup milk
approximately ½ sleeve saltine crackers (crushed)
3 to 4 boneless pork loin chops, tenderized
lard (or canola oil); enough for about ½- to ¾-inch in bottom of pan

Set up your breading stations (pie dishes work well)—one with ½ cup flour, one with the egg and milk mixed, and the other with the crackers and remaining ½ cup of flour mixed. (You can season your breading if you like with salt or seasoning salt.)

Dip each tenderloin in the flour. Coat on both sides. Dip in egg/milk mixture. Coat with cracker/flour mixture, gently pressing into the tenderloin so it sticks. Fry in hot oil/lard approximately 3 to 4 minutes on each side until cooked through.

Drain meat on paper towels. Serve on buns with desired condiments, including mustard, mayonnaise, dill pickle chips, ketchup, sliced onion, lettuce and tomato. Tenderloins can also be cut into strips and dipped in ketchup.

Bacon Mania Abounds in Iowa

While Iowans love their tenderloins, they also crave the magic that is bacon. More than twelve thousand people were expected to turn out in February 2016 for the wildly popular Blue Ribbon Bacon Festival in Des Moines. The ninth-annual event took over the Iowa Events Center for a fabulous day featuring all things bacon, from food samples to other festivities. With a theme of "Body by Bacon—Sweatin' to the Sizzle," the event incorporated workouts throughout the day, including yoga and Zumba workshops. The theme also took a jab at a health organization's proclamation that put bacon and other processed meats in essentially the same category of cancer risk as tobacco smoking.

More than fifty food vendors begged to differ, as they created more than eighty different bacon menu items. Local celebrity and Iowa farmer Chris Soules, a former participant in *The Bachelor* television show, also made an appearance to present the 2016 Bacon Festival queen with a rose made of bacon.

Iowa State University (ISU) students have also found fun ways to bring home the bacon, especially when they hosted the first annual Bacon Expo in Ames on October 19, 2013. Not only was this the first student-run Bacon Expo in the nation, but it also helped reconnect consumers with agriculture.

"People are bacon crazy," said Jake Swanson, who served as president of ISU's College of Agriculture and Life Sciences Student Council that year. The 1,200 tickets for the inaugural Bacon Expo sold out within two days. During the four-hour event, guests of all ages sampled bacon-inspired cupcakes, cookies and traditional bacon items at more than twenty vendor tents and ISU student club tents in ISU's Scheman Center courtyard.

More than 1,200 pounds of bacon were served during the family-friendly event, which also included a bacon-inspired fashion show and bacon-eating contests. "If you love bacon, thank a pork producer," said Joyce Hoppes, consumer information director for the Iowa Pork Producers Association.

While basic bacon is amazing on its own, why not take it to whole new level? Just ask my friend Cristen Clark, a pork producer from central Iowa who shares exceptional recipes on her blog "Food and Swine." Here's her inspiration for flavored bacon.

SPICY APPLE CANDIED BACON

1 pound thick-cut smoked bacon (Cristen likes Hormel Black Label Pecanwood
Thick Cut Smoked Bacon)
⅓ cup packed brown sugar
¼ cup apple butter
⅛ to ¼ teaspoon cayenne pepper
3 tablespoons white wine or apple juice*

Preheat oven to 400 degrees Fahrenheit. Place bacon strips onto a wire rack topped baking sheet. Bake strips in preheated oven for 15 minutes. Meanwhile combine brown sugar, apple butter, cayenne pepper and wine/juice in a small bowl. Stir to combine. When timer for bacon sounds, remove bacon from the oven. Spread sugar mixture onto each strip evenly. Return to the oven for an additional 10 to 15 minutes, until bacon is cooked but not yet crisp and the sugar mixture is caramelized. (Watch closely.) Remove from oven, let cool for 5 to 10 minutes and serve warm. Makes 1 pound of bacon. *Cooking times will vary based on the thickness of bacon used.

VARIATIONS:

WHISKEY SPICY PEACH CANDIED BACON: Substitute whiskey for wine and peach jam for apple butter; all other ingredients stay the same.

SPICY PEAR CANDIED BACON: Substitute pear jam for apple butter; all other ingredients stay the same.

LA QUERCIA CARVES A NICHE WITH ARTISAN PORK

Bacon is bodacious, but prosciutto and other artisan pork items produced by La Quercia in Norwalk are described as "a pig's leap into immortality." "Our goal from the beginning was to make something really good to eat," said Herb Eckhouse, who founded La Quercia with his wife, Kathy. "We seek out the best possible ingredients and craft them by hand into something that expresses our appreciation for the beauty and bounty of Iowa."

A Chicago native, Herb fine-tuned his taste for prosciutto when his career with Pioneer Hi-Bred took him to Italy. From 1985 to 1989, the Eckhouse family lived in Italy's Parma region, which is famous for its exceptional prosciutto. The Parma years provided a priceless education in local cuisine and the importance of simple, high-quality ingredients. "We learned in Italy that to eat well, you don't have to be a great preparer of food, but you do have to be a great procurer," said Herb, who began importing Italian prosciutto after he returned to America. He launched a home-based prosciutto business in 2000 before moving to the Norwalk plant.

High-quality pork also enhances La Quercia's other artisan cured meats, including speck (prosciutto that is smoked at the end of the natural dry-curing process), coppa (a richly marbled, tender piece of meat that is typically deep in color and flavor), pancetta (a type of dry cured meat, similar to bacon) and more. The Eckhouses, who have been named *Bon Appétit*'s Food Artisans of the Year, continue to develop new pork products for La Quercia. "We have a national gift in the bounty of the Midwest," said Kathy Eckhouse. "We're glad our products are putting Iowa on the map."

PORK AND BBQ

Pork is also putting Iowa on the map when it comes to barbecue. Iowa is right on 'cue, whether the smoky goodness comes from a restaurant like Jethro's BBQ in the Des Moines metro area or a backyard barbecue bash. Where's there's smoke, there's flavor, say Iowa's pitmasters. I learned this a few years ago when I interviewed Chef Shad Kirton. From his bright-pink "pig bus" to his award-winning barbecue, Kirton added his own saucy, spicy twist to pork as he traveled the competitive cooking circuit. In 2010, his culinary skills helped him win TLC's *BBQ Pitmasters* televised cooking competition, along with $100,000.

"I've competed at barbecue contests that attract a few hundred people up to seventy thousand people, and I'm always talking to the crowds as they come by," said Shad when I first met him, back when he was the executive chef at the Hotel Pattee in Perry, Iowa. "It's a great way to introduce them to the possibilities with pork."

Today's consumers can't seem to get enough advice and inspiration from chefs, who've been elevated to celebrity status thanks to the Food

Network and other media outlets. "The public has a real comfort level with chefs today, and consumers are hungry to learn new cooking methods and new recipes," said Shad, who was honored as a "Celebrated Chef" by the National Pork Board. "It's all about creating new connections between consumers and their food."

Nobody does this better than Speed "The Sauceman" Herrig of Wall Lake. "We really get into the sauce around here," joked Speed, Iowa's beloved barbecue promoter, who invested in Cookies Bar "B" "Q" Sauce in 1976 and purchased the company in the early 1980s. Great food and plenty of fun have long been a recipe for success for Speed, who lives on the same Wall Lake farm where he was raised. "I've always liked to mess around in the kitchen," said Speed, who learned a lot about cooking from his mother, Alma. "Because of food, I've met lots of great people and even got to cook for President George H.W. Bush during the World Pork Expo a number of years ago."

When Speed collected more than 350 of his favorite recipes for his 2005 cookbook, *Cookie's Best BBQ Recipes*, he made sure that nearly all the ingredients in his recipes can be found in any small-town grocery store. Giving back and making life a little easier for others is second nature for Speed, a founding member of the Iowa Barbecue Society (IBS), who has shared his cooking expertise with underprivileged Iowa youth through Refining Individual Barbecue Skills (RIBS) for Kids. Don't expect Speed to tone down his busy schedule anytime soon, however, even though many of his contemporaries have been retired for years. "I'm having so much fun doing this that I'm going to keep on going," he told me.

For Speed and other pitmasters, the secret to great barbecue is all about low and slow. I got a taste of this when I stopped by the 2013 Webster County Fair in Fort Dodge. As I visited with Matt Nahnsen, who was participating in the barbecue contest, it was hard to resist the tempting aroma of succulent pork ribs as he lifted the lid periodically on his Char-Griller Smoker to mist the meat with apple juice. Matt knows that great barbecue starts with great pork, along with the right seasoning. Here's one of the recipes he relies on.

Big Dog Daddy's BBQ Rub

5 cups brown sugar
3 tablespoons kosher salt
3 tablespoons black pepper

2 tablespoons minced onion
2 tablespoons garlic
1 tablespoon crushed red pepper
1 tablespoon basil
1 tablespoon thyme
1 tablespoon oregano
1 tablespoon cumin

Mix all ingredients together and store in a plastic container. To season ribs, select a meaty cut like St. Louis–style ribs and remove the membrane on the back of the rack of ribs. Cut a row of diagonal cuts both ways on the both sides of the ribs. Massage the spice rub into both sides of the ribs.

Place the rack of ribs, bone side down, and slowly smoke the ribs on low heat for 3 to 4 hours, until the meat reaches the desired tenderness. Spritz the ribs every 15 to 30 minutes with apple juice. Add your favorite BBQ sauce at the end and cook for a few minutes more to allow the sauce to caramelize for extra flavor.

If using an oven instead of a smoker, set the oven to 250 degrees. Season the ribs with Big Dog Daddy's BBQ Rub. Pour a few cans of beer into the pan before adding the ribs and cook until the meat reaches the desired tenderness.

DEDHAM'S FAMOUS BOLOGNA TURNS ONE HUNDRED

The story of unique Iowa meats isn't complete without the state's meat lockers, such as Kitt's Meat Processing in the western Iowa town of Dedham. There's hardly anything in Dedham that hasn't changed dramatically since 1914, yet one tradition stays the same in this small Carroll County town: its famous bologna. "This recipe has been handed down for one hundred years," said Dave Kitt, who owns Kitt's Meat Processing in Dedham with his wife, Shawn. "Every meat locker has a specialty, and ours is Dedham bologna."

It's such an important part of the business, in fact, that the company's slogan is the "Home of Dedham Bologna." While no one quite remembers who created the original recipe in 1914, the smoky, beefy rings reflect the area's German heritage. Dedham bologna is predominantly beef, with some

pork included in the natural casings, which are all tied by hand. The mild rings are hickory smoked for three and a half hours, resulting in a meaty celebration for the senses that's fully cooked and ready to serve.

Local history books note that people saved their ration stamps during World War II to buy Dedham bologna, which was enjoyed at home and mailed to servicemen from the area. In years past, the downtown Dedham Meat Market would open up after Sunday Mass so families from the St. Joseph parish could purchase Dedham bologna for Sunday brunch or dinner.

As the locals have known for generations, there are countless ways to enjoy Dedham bologna, which can be eaten hot or cold. At Kitt's Meat Processing, an electric skillet makes it simple to serve the crew a fast, hearty lunch of Dedham bologna fried with butter, potatoes and onions.

Some people like to include Dedham bologna on meat and cheese trays, while other people grill it, serve it with scrambled eggs, pair it with sauerkraut, use it as a pizza topping or chop it up like ham salad, Shawn Kitt said. "Customers come up with all kinds of creative ways to use Dedham bologna."

When I stopped by Dedham in 2014, I visited with ninety-four-year-old Helen Wiskus, a Dedham native who had been enjoying this unique culinary tradition all her life. "Dedham bologna has always been big here," Helen informed me. "When the family gets together, the Dedham bologna comes out."

It's a piece of culinary history that Shawn Kitt is happy to preserve. "We're proud to keep the Dedham bologna tradition going."

SKOGLUND MEATS OFFERS A TASTE OF WEST BEND

Tradition also defines Skoglund Meats and Locker in West Bend. From Dobberstein smoked sausages to Mikes Wieners, time-honored recipes unique to West Bend have helped Skoglund Meats and Locker create a taste of place and tell the story of this northwest Iowa town. "If you want to survive in this business, you've got to be unique," Mark Skoglund told me when I interviewed him in 2006.

The Dobberstein sausage recipe that Skoglund revived originated decades ago when Father Paul Matthias Dobberstein, creator of West Bend's Grotto of the Redemption (a religious shrine frequently considered the "Eighth Wonder of the World" and called the "Miracle in Stone"),

requested a sausage like ones he remembered from his native Germany. Dobberstein, who lived in West Bend from 1898 to his death in 1954, worked with the local meat market to create the rich, smoky flavor he craved. The sausage was a piece of home away from home and remains a perennial favorite at Skoglund Meats and Locker.

The story of Mikes Wieners began at the turn of the twentieth century when Adolph Mikes and his family emigrated from Czechoslovakia to the United States, bringing with them an old-world recipe for wieners. Sons Frank, Paul and Harold worked for years in Mikes Meat Market on Main Street in West Bend, producing the now famous Mikes Wieners until 1988. Due to popular demand, Skoglund Meats and Locker purchased the recipe in 2002 and began producing these delicately seasoned, corncob smoked, all-meat/natural-casing wieners.

While Mikes Wieners, Dobberstein sausages and other specialties at Skoglund Meats generate economic development for the local community, they reflect something even more meaningful to Iowans—a taste of home.

Graziano Family Brings a Taste of Italy to Iowa

Great sausage isn't just found in Iowa's small towns. Ask any good Iowa cook who knows a thing or two about high-quality sausage, and you'll likely hear the name "Graziano's." Foodies across the state rely on Graziano Bros. Italian Foods' best-selling medium-hot sausage, sweet sausage and more to elevate the flavor of their favorite dishes, from pastas to soups.

The story of Graziano Bros. Italian Foods started more than a century ago with brothers Francesco (Frank) and Luigi (Louie) Graziano. Born in San Morello in the Calabria region of southern Italy, the brothers began their life in a loving but impoverished family. By 1903, the two brothers did what many Italians dreamed of, immigrating to America. After Frank, twenty-one, and Louie, seventeen, made their way to Iowa, they found jobs with the Great Western Railway.

Railroad work was tough, but it helped sustain the brothers, who settled in an Italian neighborhood in the "South Side Bottoms," south of downtown Des Moines. Never afraid of hard work, the Grazianos were entrepreneurs at heart. It was decided that Louie would start a corner grocery in 1912, while Frank would continue working for the railroad to support the brothers until the new business was established.

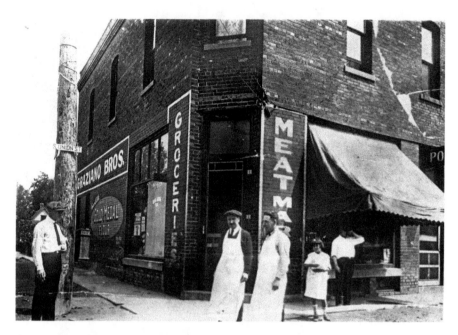

Graziano Bros. Italian Foods in Des Moines was started in 1912 by brothers Francesco (Frank) and Luigi (Louie) Graziano. The Grazianos quickly became known for their homemade sausage, which was based on the flavor they remembered as children growing up in Italy. Graziano's small grocery store thrived and is still located on South Union Street. *Courtesy of Graziano Bros.*

The Grazianos quickly became known for their homemade sausage, which was based on the flavor they remembered as children growing up in Italy. Graziano's small grocery store on South Union Street thrived and grew. Frank and Louie worked well together and were able to help many of their friends and neighbors, even through the Great Depression. "Extending this credit to customers in need almost broke the business, but we still have descendants of those people who patronize our store and tell us how much that generosity meant to their family," said Frances Graziano, who runs the company founded by her grandfather and great-uncle. "People remember how you treat them."

Graziano's patrons are more than customers, emphasized Frances, who became company president in 2000. "Everyone is family here." Part of this sense of family stems from the close-knit Italian American neighborhood where Graziano's has been located since 1912. At the heart of this community is St. Anthony Catholic Church and the local parochial school, not far from the Italian American Cultural Center of

Iowa. "We have a rich culture and are proud to maintain these traditions," Frances said.

For locals, one of these traditions includes regular visits to Graziano's, where rich, spicy aromas greet visitors as soon as they walk in the front door. Many customers stop by to purchase the best in homemade Italian sausage made from high-quality pork and Italian seasoning. No preservatives are added to the sausage, which is sold in link, bulk and patty forms. Graziano's, which caters to both the retail and wholesale markets, primarily serves a forty-five-mile radius around Des Moines, although its famous sausage can be found across the state at various grocery stores. Customers also appreciate the wide selection of the finest Italian cheese imports, cured meats from pancetta to capicola, Italian pasta sauces, San Marzano tomatoes, pasta and a variety of sweets, including biscotti, cannoli and more.

From humble beginnings, Frank and Louie Graziano created a rich cultural legacy not just for their families but for generations of Iowans who crave a taste of Italy. "Italian Americans have made many contributions to the history of Iowa and its culinary heritage," Frances said. "Food is an important way to maintain these traditions."

On a side note, while some Italian immigrants like the Graziano brothers worked for the railroad in Iowa, many also worked in the state's coal mines in the late nineteenth and early twentieth centuries. Mining was a physically demanding, dirty job that coated the workers' skin with grime. When these men emerged from the mine after a long workday, they were as black as guinea fowl. While Italian grinder sandwiches were once called "guinea grinders" at events like the Iowa State Fair, this slur had started to disappear by the 1990s. This recipe for Italian grinders comes from Chef George Formaro, a Des Moines native who grew up on sausage and other fine products from Graziano Bros. Italian Foods.

Italian Grinders

2 pounds fennel Italian sausage (Graziano's is worth the road trip)
1 15-ounce can tomato sauce
½ teaspoon garlic powder
½ teaspoon onion powder
1 pinch dry basil
hoagie buns
mozzarella cheese, shredded

Cook sausage, stirring constantly. When sausage is done, add remaining sauce and herbs and cook on low heat for another 20 to 30 minutes, stirring constantly. Place sausage mixture into hoagie buns and top with mozzarella cheese. Place the Italian grinders in a preheated, 400-degree oven or a toaster oven until bread is toasted and cheese is melted.

LET'S TALK TURKEY

While pork and beef are a big part of Iowa's culinary history, so is turkey. Iowa is among the top ten turkey-producing states in America. Both Subway and Jimmy John's restaurants serve Iowa turkey. You can also find Iowa-grown turkey in your grocery store via Jimmy Dean and private-label sliced turkey.

Iowa's turkey industry includes 130 turkey farms that raise 11 million turkeys annually, according to the Iowa Turkey Federation. Two major processing plants in Storm Lake in northwest Iowa and West Liberty in eastern Iowa process millions of turkeys each year.

The official "pardoning" of White House turkeys at Thanksgiving is a unique tradition that has captured the public's imagination for years. In 1988, President Ronald Reagan participated in this event, which included National Turkey Federation director Lou Walts (second from left), along with Pete Hermanson (to the right of the turkey) and his wife, Janet, who were turkey producers from Story City, Iowa. *Courtesy of the Iowa Turkey Federation.*

Turkey has become a favorite among people of all ages who visit the Iowa Turkey Federation's food tent at the Iowa State Fair. Kids love the turkey legs, while grilled turkey tenderloins are also a hit. This recipe is the one the Iowa Turkey Federation has used on the marinated and grilled turkey tenderloin sandwiches served at the Iowa State Fair for more than thirty years.

Iowa's Grilled Turkey Tenderloin

2 tablespoons lemon juice
¼ cup soy sauce
¼ cup vegetable oil
¼ cup dry sherry or red wine
2 tablespoons dehydrated onion
¼ teaspoon ginger
⅛ teaspoon black pepper
⅛ teaspoon garlic powder
1 pound turkey tenderloins

To make the marinade, mix all ingredients (except turkey tenderloins) together in a plastic bag or storage container. If desired, slice the turkey tenderloins in half lengthwise to make two thinner fillets or slice in half to make two long, circular shapes. Combine turkey with marinade and refrigerate for several hours.

Grill marinated turkey over hot coals 6 to 8 minutes per side, or until a meat thermometer registers 170 degrees and the middle of the meat is no longer pink. If desired, serve on a hot dog or hoagie bun.

Turkey isn't just for the Iowa State Fair or Thanksgiving. Ever tried a turkey dressing sandwich? In northeast Iowa, nothing beats turkey dressing sandwiches, a flavorful mixture of turkey, gravy and stuffing mixed together and served in a bun. "These sandwiches are a staple around here," said JoAnne Gregorich, whose family farms near La Motte in eastern Iowa, south of Dubuque.

If you attend enough graduation parties, bridal showers or wedding receptions in parts of eastern Iowa, there's a good chance that turkey dressing sandwiches will be on the menu. This regional favorite is so ubiquitous that

In parts of northeast Iowa, turkey dressing sandwiches are a favorite food that combines a flavorful mixture of turkey, gravy and stuffing mixed together and served in a bun. They are a staple at countless graduation parties, wedding receptions and holiday gatherings, especially in the Dubuque area. Many locals head to Cremer's, a longtime corner grocery in Dubuque, to buy huge pans of turkey dressing goodness. *Author's collection.*

it has been highlighted in Distinctively Dubuque, a five-week seminar that welcomes newcomers to the Greater Dubuque area and showcases the culture, history and traditions that make the region unique.

There often are no specific recipes for turkey dressing sandwiches, and every family has their own twist on this local classic. While some turkey dressing sandwiches tend to be "starch on starch," the Gregorich family prefers to go heavy on the turkey. "I'd say I use about 95 percent turkey, along with a little stuffing and gravy," said JoAnne, who added that leftover cranberry sauce on the side is a good option.

What if you pour gravy on top of a turkey dressing sandwich, similar to a hot beef sandwich? "That's something different than a turkey dressing sandwich," JoAnne confirmed. Here's the general concept for northeast Iowa's turkey dressing sandwiches, which can be prepared in slow cookers, roasters or baking pans. If you're in the Dubuque area, you can also purchase turkey dressing goodness at Cremer's Grocery, a family-owned neighborhood grocery store and Dubuque institution since 1948 that's known for its high-quality meat department.

Turkey Dressing Sandwiches

leftover turkey
dressing (can also use a box of stuffing mix)
gravy
buns
cranberry sauce, if desired

Combine the first three ingredients. The amount of each ingredient will depend on your personal taste. The filling can be kept warm in a slow cooker until it's time to serve. Place the turkey dressing filling in buns. Cranberry sauce can be served on the side, if desired.

Chapter 5

SMALL-TOWN LIFE

While some of the earliest towns in Iowa were established near the Mississippi River, the arrival of the railroad in the 1850s unleashed a wave of settlement across the state that accelerated dramatically following the Civil War. As rail lines began to crisscross Iowa, new towns sprang up practically overnight as the "iron horse" brought settlers and supplies to the far corners of the state. The rail made it possible for Iowa's growing farms to ship livestock and other commodities to Chicago and other markets in the East. Rail service also meant that a wider variety of foods could be delivered to general stores in small towns across Iowa in the latter part of the nineteenth century, as well as to locally owned grocery stores in later decades.

Many of these stores served small towns that have ceased to exist. While communities like Panther, Moran and Sherwood are now ghost towns, Iowa is still characterized by the hundreds of small towns scattered across the state (roughly 947 to be exact, as of 2010). In many of these communities, small-town life, farm life and Iowa's culinary history have been closely intermingled for decades.

Ingalls Family Lived in Burr Oak

Nestled in one of the most beautiful areas of northeast Iowa is the village of Burr Oak (named in honor of the area's abundant groves of burr oak trees,

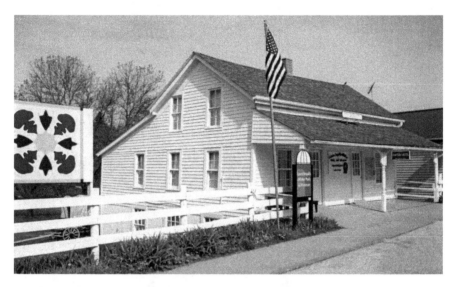

In 1876, Charles Ingalls and his family (including daughter Laura, who would become the famed author of the *Little House* books) moved from Walnut Grove, Minnesota, to Burr Oak, Iowa, to run the Masters Hotel. Caroline Ingalls ("Ma") cooked meals for the boarders, providing breakfast, dinner and supper daily. The Ingalls family moved on within a year. *Courtesy of Laura Ingalls Wilder Park and Museum.*

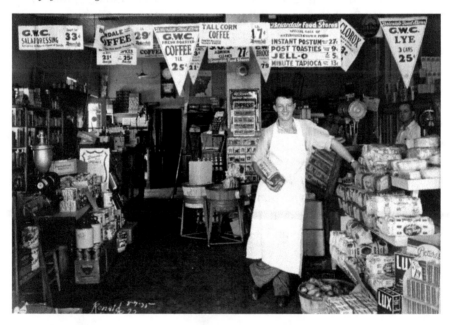

For generations, independently owned small-town grocery stores like this one in Somers were common in communities across Iowa. This store, which was owned by Floyd Richie, is shown in August 1935. Note that Tall Corn Coffee cost only seventeen cents per pound. *Courtesy of Somers Public Library.*

the state tree of Iowa). Settled in 1851, the community boasted roughly two hundred people by 1880. It was around this time that the small community welcomed its most famous residents.

In the late 1870s, Charles Ingalls and his family (including daughter Laura, who would become the famed author of the *Little House on the Prairie* books) moved from Walnut Grove, Minnesota, after suffering through two years of grasshopper plagues, to Burr Oak to run the Masters Hotel. Burr Oak was a major crossroads in that era. It wasn't unusual for two hundred and sometimes three hundred migrant wagons to pass through Burr Oak each day.

The Masters Hotel was owned by the Ingalls family's friend William Steadman, also from Walnut Grove. (Burr Oak is often referred to as the "missing link" in the *Little House* book series, since Laura didn't mention it in her books.) In 1876, when Laura Ingalls was nine years old, Charles Ingalls and his family moved into the hotel with the Steadman family. Caroline Ingalls ("Ma") cooked meals for the boarders, providing breakfast, dinner and supper daily. The meals were prepared in the hotel basement on a cookstove and served at tables in a dining area near the kitchen and pantry in the basement. The Masters Hotel was not a spacious, fancy establishment, and quarters were cramped. This was also not the opportunity the Ingalls family had hoped for, and they moved on within a year.

The Masters Hotel, which is on the National Register of Historic Places, is the only childhood home of Laura Ingalls Wilder that remains on its original site. Visitors can tour the hotel and see the small garden that reflects the types of herbs that Ma Ingalls might have used not only for cooking but also for medicinal purposes. Even if you can't make it to Burr Oak, you can still eat like the Ingalls family, thanks to this recipe I received when I visited Burr Oak in 2015.

MA'S BEST BUTTER COOKIES

1 stick butter (unsalted)
½ cup light brown sugar
1 egg
1 teaspoon vanilla
1½ cups flour
½ teaspoon salt

½ teaspoon baking soda
½ teaspoon powdered ginger
2 tablespoons granulated sugar

Make sure the butter is at room temperature. Cream butter and brown sugar. Add egg and vanilla to the mixture. Mix well. In a separate bowl, combine flour, salt, baking soda and powdered ginger. Combine the dry and wet ingredients. Mix thoroughly.

Put the 2 tablespoons of sugar in a small bowl. Scoop balls of dough and gently roll dough in the sugar, coating the outside of each cookie generously. Place the dough balls on an ungreased baking sheet, with cookies about 1½ inches apart. Gently press a fork into the top of each cookie to make a simple design.

Bake at 375 degrees for 12 minutes, or until cookies are lightly browned. Remove from oven. Transfer cookies from baking sheet to cooling rack. Yields 2 dozen cookies.

HOMESTEADERS RECALL WHEN THE NEW DEAL CAME TO GRANGER

In the 1930s, one small central Iowa town became the focal point of a New Deal program from President Franklin D. Roosevelt that revolved around food, gardening and self-sufficiency. "There was definitely a need for the Granger Homestead project," recalled Chuck Fuson, a Granger resident who grew up in the Homesteads and was seventy when I interviewed him around 2004.

Fuson's father worked in the coal mines located throughout Dallas County. During the Great Depression, the large family could barely make ends meet. Fuson said that their shabby, drafty, rodent-infested home in Grimes was no place to raise children. "I believe my younger brother Jerry, who was born in October 1941, wouldn't have survived if we had been forced to stay in that house. But then we had the chance to move to the Granger Homesteads in December 1941."

Built in 1935, the 225-acre Granger Homesteads included fifty new houses that came complete with approximately four acres of land that "homesteaders" could use to raise crops and livestock. "Federal officials who funded the project didn't consider this to be a relief effort, so only

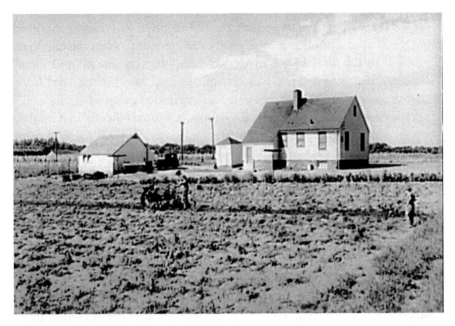

In the 1930s, one small Iowa town became the focal point of a New Deal program from President Franklin D. Roosevelt that revolved around food, gardening and self-sufficiency. Built in 1935, the 225-acre Granger Homesteads in Dallas County included fifty new houses that came complete with about four acres of land that the "homesteaders" (typically low-income miners in the area) could use to raise livestock and crops, including potatoes. *Courtesy of the Library of Congress.*

people employed at least half time would be considered," explained Donna Manning, whose Italian immigrant grandparents moved into the Homesteads in 1935. "The goal of this project was to enable the miners to make it on their own. They had the chance to buy their home and the ground it was on without the burden of owing their life to the coal company they worked for."

The Homesteads marked a dramatic change for the families who moved in during the Great Depression and World War II. Most came from coal mining camps, known for their squalid housing conditions, meager social opportunities and high illiteracy rates. Through her research, Manning discovered that a typical twenty-four-square-foot mining camp house had no indoor plumbing and rented for six to eight dollars per month.

"There seemed to be no end to the miners' plight," she said. "Few of the families had automobiles so they could drive into town. Also, every summer it was anticipated that two or three mining camp children would drown while swimming in the nearby Des Moines River."

Father Luigi Ligutti, who became the parish priest in Granger in 1926, found the coal camps to be a totally unfit environment for raising children. He looked to the land as a remedy for the miners' economic and social challenges. The young priest had brought a deep love for the land from his native Italy, and his years in Iowa had intensified that feeling. In 1932, Ligutti addressed a convention of Catholic Church officials in Omaha, where he shared his philosophy that the farm was the ideal place to raise children. "Ligutti's ideas weren't well received," Manning said, "but that didn't deter him at all."

In December 1933, Ligutti filed a petition for the Granger Homesteads. Ligutti considered the Granger area to be an ideal site for the project, Manning said. With good farmland, residents could enjoy the advantages of rural living, Ligutti believed. In addition, the project would be located a short distance from a community, where homesteaders could benefit from the local churches and schools.

Ligutti's petition called for the building of fifty homes on 225 acres half a mile outside the town of Granger, with fifty families being chosen from the families residing in the area's nine different coal camps. The houses would range in size from four to six rooms, each with a full basement, a hot-air furnace, a hot-water heater and an automatic pressure tank connected to an electric well pump. The average land per home was about four acres, making the average available land for cultivation about 3.5 acres.

On March 15, 1934, the U.S. secretary of the interior announced that the subsistence homesteads project at Granger would be funded. The estimated cost of the project was $100,000. The average cost of the homes totaled $3,500, and the families had thirty years to pay for the land and their home, at an interest rate of 3 percent.

The homesteaders included Catholics, Protestants and various ethnic groups, including Italians and Croatians. "The town of Granger was not at all happy about the immigrants," Manning recalled. "They feared the area would begin to look like a slum. Local farmers also feared that the homesteaders' farm and garden produce would mean increased competition for them."

The Granger Homesteads proved the critics wrong, however, and became of the most successful of the federal government's subsistence homestead projects, Fuson noted. The families supplemented their income by raising a variety of crops and livestock. With Ligutti's support, the homesteaders also formed cooperatives to buy farm equipment and sponsor recreational

activities. In 1936, President Roosevelt's wife, Eleanor, visited the Granger Homesteads and praised the success of the project.

While the entire project ended up costing the federal government about $200,000, within twenty years the homesteaders had paid back most of that amount, and no families defaulted on their loan. When the Granger Homestead Association was dissolved in 1951, the residents had achieved their goal of homeownership. Some of the original Granger Homesteads houses are still inhabited.

"Father Ligutti had a great vision for the possibilities," Manning said. "The heritage we have because of the Granger Homesteads is very special, and I'm proud that my family played a part in it."

SEASONAL SENSATION: POKEY'S CARAMEL APPLES KEEP CARROLL TRADITION ALIVE

The families who moved to the Granger Homesteads had the chance to plant their own crops and grow their own food. Apples could have been one option.

Apples were big business in Iowa in years past, especially in the late 1880s and early 1900s. In the 1870s, Madison County farmer Jesse Hiatt developed the famous Red Delicious apple, which he named the "Hawkeye." (The "Hawkeye Red Delicious" is still grown at Wilson's Orchard near Iowa City, where you can enjoy a taste of this Iowa original, along with the orchard's famous apple turnovers.)

Iowa became a top apple-producing state, with peak production at 9.5 million bushels in 1911. Iowa remained a leader until the mid-1920s, when row-crop agriculture expanded in the state, and Iowa faced greater competition from apple-producing states like Washington, Michigan and New York.

Iowa's apple industry was dealt a devastating blow by a severe freeze on November 11 (Armistice Day) in 1940 that killed or severely injured many apple trees. Many Iowa apple growers decided not to replant their orchards, and the apple industry dwindled in its economic importance to Iowa.

Apples still play a key role in Iowa's culinary heritage, however, especially in Carroll, home of Pokey's Caramel Apples. "The caramel apples are a great tradition in this community," said Gina Nelson, whose family has been making this seasonal treat for nearly eighty years. "People truly love them and look forward to them each fall."

The Nelsons rely on a secret family recipe to make thousands of creamy, sweet caramel apples to meet the tremendous demand each fall. Pokey's products are only available at the Hy-Vee grocery stores in Carroll and Denison, and they highlight the appeal of local foods. "Food is more personal today," said Jason Sheridan, who was the Hy-Vee store director in Carroll when I talked to him a few years ago. "Many consumers want a connection to the people who produce their food, so we like to showcase local products. When Pokey's season arrives, it's almost like the kickoff to fall around here."

The time-honored tradition of Pokey's Caramel Apples dates back to 1938, when Gina Nelson's grandfather Ottavio Pollastrini began operating a candy kitchen in Carroll. It was a natural fit for Pollastrini, who was raised in Collodi in northern Italy, a region known for candy and Chianti.

"Candy making is a tradition in Tuscany," said Gina, who noted that Pollastrini came to America as a boy and later worked with his older brothers in Chicago and Clinton (where his brother Amos ran a candy kitchen) before deciding to start his own business. Shortly after purchasing the Carroll Candy Kitchen from the Marcucci family, Pollastrini introduced western Iowa to caramel apples in the fall of 1938.

Caramel apples weren't a big seller right away, noted Betty Pollastrini, who married Ottavio's son, Ray, in 1954. "The farmers thought it was crazy to 'ruin' a perfectly good apple with caramel. As people began to taste them, however, they thought caramel apples were the best treat they could buy."

Through the years, the family's candy kitchen evolved into a downtown café. After Ray and Betty Pollastrini began running the business in 1957, the café was renamed in honor of the family patriarch, who was affectionately called "Pokey." "Grandpa Ottavio was known for poking around town and visiting friends when he should have been making candy," said Gina, who noted that Pokey's copper kettle continues to be fired every fall to usher in the caramel apple season.

Pokey's Caramel Apples continued to grow in popularity, thanks to events like Band Day, which was held each fall in Carroll. Pokey's Café was located midway through the downtown parade route, where high school marching bands from West Des Moines and beyond performed. "Band Day was by far the biggest-selling day of the year for our caramel apples," said Betty Pollastrini, who recalled that the apples cost customers $1.25 back then, compared to $2.75 today.

After Pollastrini and her husband decided to sell their business in 1997, the new buyer wanted the café but not the caramel apple equipment. The Pollastrinis' daughter, Gina, and her husband, Dave Nelson, opted to take

over the caramel apple business. Along with the secret recipe, they acquired the large copper kettle, wooden paddle, gas stove, candy thermometer and marble table that the family had used to make caramel apples since 1938.

Ray Pollastrini guided the Nelsons every step of the way during the transition. "We still use all this same equipment and follow the same caramel recipe," said Dave, who makes the caramel in a small kitchen in the corner of the family's basement at their home in Carroll.

Like the Pollastrini family, the Nelsons use apples from Deal's Orchard, a third-generation family business in Jefferson. Caramel apple production kicks into high gear in early September, once the Jonathan apples are ripe. "Jonathans are firm and sweet, but not too sweet," Dave told me when I stopped by his home a few years ago to see the caramel apple production process. "A little tartness with the caramel is a good combination."

Timing is everything to make Pokey's famous caramel with just the right flavor and texture. "You have to watch it continuously," said Dave as he stirred a batch of the bubbling, golden liquid that will coat about two hundred apples. "Once the caramel starts boiling, you must stir it for about an hour."

The Nelsons sometimes produce a batch or two a day during the caramel apple season, which runs from early September through late October or early November. "Our apples are tailgating favorites with local Iowa State Cyclones and Iowa Hawkeye football fans," said Gina, who added that Pokey's Caramel Apples have also been shipped to members of the U.S. military serving overseas. People's gratitude means a lot, said Betty Pollastrini. "It's a thrill to see this family tradition carry on."

BEAN SOUP HIGHLIGHTS FALL FESTIVAL AT HARRIMAN-NIELSEN FARM

Other small-town traditions across Iowa also focus on food. The Harriman-Nielsen farm in the north-central Iowa town of Hampton remains a time capsule of Danish history in Iowa. The final owners of the home, Chris and Anna Nielsen, emigrated from Denmark in 1905 and purchased the property in 1920. They operated the Whiteside Dairy there for twenty-five years.

The Nielsens left a variety of antiques, including Danish hand-painted dishes, that remain in the farm home. They also preserved more than two thousand letters written to family and friends in Denmark. Visitors can get a glimpse of this Franklin County heritage during the popular Fall Festival

at the farm. More than one thousand guests attended the festival in 2015. No Fall Festival would be complete without the delicious bean soup, which is made from heirloom beans grown in the garden at the Harriman-Nielsen farm. In 2015, volunteers prepared seven roasters of the famous bean soup, along with nearly seventy-five homemade pies.

Bean Soup

1½ cups beans
2 smoked ham hocks or ham shanks
½ cup finely chopped celery
¼ cup chopped carrots
½ cup chopped onion
2 cans fire roasted tomatoes
1 package onion soup mix
6 cups water
1 tablespoon lemon juice

Rinse beans and soak overnight; you will need to soak the beans overnight in three times the amount of water as beans. Drain and place all ingredients in a large covered kettle and simmer until beans are tender. Salt to taste. Cook all ingredients for 8 hours on low in a slow cooker. Remove the ham hocks and take off the meat after it is thoroughly cooked. Return meat to slow cooker. Serve with a side of crispy bread and a salad, and you have a great fall meal.

Breitbach's Country Dining Offers a Taste of History

Years of tradition also define many of Iowa's classic small-town restaurants, from diners to drive-ins. Take Breitbach's Country Dining in Balltown near the Mississippi River. This tried-and-true favorite has more than stood the test of time. Iowa's oldest food and drinking establishment was opened in 1852 by federal permit issued from President Millard Fillmore.

Breitbach's Country Dining

Welcome To Iowa's Oldest
Established Bar & Restaurant

Balltown, Iowa - Est. 1852

BREAKFAST & LUNCH MENU

Breitbach's Country Dining in Balltown near the Mississippi River is Iowa's oldest food and drinking establishment. Opened in 1852 by federal permit issued from President Millard Fillmore, the restaurant has survived two devastating fires and remains family-owned and operated. *Courtesy of Breitbach's Country Dining.*

Jacob Breitbach, great-great-grandfather of the present owner, worked for the business's original owner and purchased the tavern in 1862. Since that time, the Breitbach family has been in continuous ownership of the historic establishment, which is now in its sixth generation. Breitbach's Country Dining makes everything fresh from scratch, from delicious homemade soups (including its signature spaghetti soup) to sandwiches, salads and pies (like its classic peanut butter pie). Dinners feature steaks, prime rib, chicken and a variety of seafood entrées. Unlike an earlier era that prohibited women from entering the bar, today everyone of age is invited to enjoy their favorite beers, wine and cocktails.

Breitbach's has faced its share of tragedy, however. In eighteen months, Breitbach's Country Dining was struck by fire and completely destroyed not once, but twice. The first fire, which destroyed the 150-year-old family business, happened on December 24, 2007. It didn't take long for the community and others from all over the area to rally around the Breitbach family and help them rebuild.

Ten months to the day after the first fire, on October 24, 2008, owner Mike Breitbach received a call at 3:30 a.m. that his building was on fire. The family and whole community were in shock once again. After the second blaze, the thought of rebuilding was more difficult. Just before Christmas 2008, however, Mike and his family announced that they would once again rebuild Iowa's oldest bar and restaurant.

People come from far and wide to enjoy the homestyle cooking that helped Breitbach's Country Dining receive the highest award a restaurant can receive. In 2009, the James Beard Foundation honored Breitbach's Country Dining with its "American Classics" award.

GET CRONK'ED ALONG THE LINCOLN HIGHWAY

Another classic is Cronk's Café in the western Iowa town of Denison. Continuously operated since 1929, Cronk's has been a destination for decades, first with travelers (including big-band leader Lawrence Welk) traversing the legendary Lincoln Highway and now with presidential candidates, who stop for dinner and a speech to rally supporters prior to the Iowa Caucus. (Dr. Ben Carson was one of the most recent presidential hopefuls to hold a rally at Cronk's in January 2015 and attracted more than two hundred people to the event.)

Cronk's offers a feast for the eyes and the palate. Lots of big Hollywood and Washington, D.C., names have dined here. A wall in the lounge area showcases photos of Iowa's own Donna Reed, the movie and television star who put Denison on the map. Cronk's also has copies of its vintage 1940s-era menu, when pure orange juice cost ten cents, French toast was twenty-five cents and a No. 6 (complete with three strips of bacon, two slices of toast, jelly and coffee) cost thirty cents. While prices have changed, Cronk's still retains its small-town café atmosphere, along with its reputation for hearty, flavorful meals (including classic fare like hot beef sandwiches and unexpected items like pork burgers) and a slice of pie for dessert.

"It's getting tougher for independent, mom and pop restaurants like this to compete, but I'm glad to be part of this tradition," said Eric Skoog, who has owned Cronk's with his wife, Teri, for more than thirty years.

REED-NILAND CORNER BRINGS THE PAST TO LIFE

Another Iowa icon along the Lincoln Highway is the historic Reed-Niland Corner in the Story County town of Colo (population 876). Located at the intersection of the Lincoln Highway (which spans roughly 3,389 miles from New York City to San Francisco) and the Jefferson Highway (a "pines to palms" international route which ran from Winnipeg, Canada, to New Orleans), the Reed-Niland Corner got its start in the 1920s. It provided the perfect location for weary travelers to fill up their vehicle with gasoline, enjoy a home-cooked meal at the L&J Café and enjoy a good night's sleep at the cabin court. "For a few years, the café was the only twenty-four-hour operation around," recalled Joan Niland, whose family used to run the business. "The employees would always joke that we never had a key for the front door."

Right: Cronk's Café, a Denison tradition since 1929, has copies of its 1940s-era menu, when pure orange juice cost ten cents, French toast was twenty-five cents and a No. 6 (complete with three strips of bacon, two slices of toast, jelly and coffee) cost thirty cents. *Courtesy of Cronk's Café.*

Below: One Iowa icon along the Lincoln Highway is the historic Reed-Niland Corner in the Story County town of Colo. Located at the intersection of the Lincoln Highway and the Jefferson Highway, the Reed-Niland Corner got its start in the 1920s so travelers could fill up their vehicle with gasoline, enjoy a home-cooked meal at the L&J Café and relax with a good night's sleep at the motel. Guests can still dine on tasty Iowa fare at Niland's Café and stay at the motel next door. *Author's collection.*

Cronk's

BREAKFAST Specials

Pure Orange Juice10c
Tomato Juice10c
Choice of Cereals,
 half and half 15c
Wheat Cakes and Coffee...20c
Sliced Oranges10c
Sweet Rolls and Coffee10c
One-Half Grapefruit10c
Canned Grapefruit10c
One-Half Cantaloupe
French Toast25c
Milk Toast20c
Dry or Buttered Toast10c
Cinnamon Toast15c
Melba Toast10c

We Serve
Folger's Coffee
Exclusively

ORDER BY NUMBER

No. 1 - 25c
Oatmeal with Cream, Two Slices Toast, Jelly and Coffee

No. 2 - 35c
Two Wheat Cakes or Toast, One Fried Egg, Two Strips Bacon with Coffee

No. 3 - 35c
One Egg, Two Strips Bacon, Toast, Jelly and Coffee

No. 4 - 30c
Two Eggs any Style, Two Slices Toast, Jelly and Coffee

No. 5 - 40c
One Egg, Side Ham, Two Slices Toast, Jelly and Coffee

No. 6 - 30c
Three Strips Bacon, Two Slices Toast, Jelly and Coffee

No. 7 - 30c
Two Cakes, Three Strips Bacon and Coffee

No. 8 - 45c
2 Strips Ham or Bacon and Eggs, Toast, Jelly, Coffee

No. 9 - 30c
Two Cakes, Two Fried Eggs and Coffee

No. 10 - 30c
Ham, Two Slices Toast, Jelly and Coffee

No. 11 - 30c
Two Buckwheat or Corn Cakes, Sausage and Coffee

SPECIAL WAFFLE MENU

No. 12 - 20c
Creamed Waffle, Butter, Maple Syrup and Coffee

No. 13 - 30c
Creamed Waffle, Butter, Maple Syrup, 2 Eggs, and Coffee

No. 14 - 35c
Creamed Waffle, Butter, Maple Syrup, Side of Sausage and Coffee

No. 15 - 40c
Creamed Waffle, Butter, Maple Syrup, Three Strips of Bacon and Coffee

No. 16 - 40c
Creamed Waffle, Butter, Maple Syrup, One Pork Chop, One Egg and Coffee

No. 17 - 40c
Creamed Waffle, Butter, Maple Syrup, Fried Ham and Coffee

No. 18 - 35c
Missouri Waffle, Butter, Maple Syrup, Two Strips Bacon Fried in Waffle

With the motto "A good place to eat, where friends meet," the business catered to both travelers and locals. In an era when meals were breakfast, dinner and supper (not breakfast, lunch and dinner), the café served up specials including chicken and noodles, salmon loaf and minute steak, as well as menu standards like homemade bean soup, made with beans soaked overnight and cooked with a ham hock.

Today, the restored complex is the only complete, one-stop destination of its type along the entire length of either the Lincoln or Jefferson Highways, noted owner Sandra Huemann-Kelly. The neon sign on the roof and colorful black-and-white checkerboard flooring transport you to an earlier era as you walk into the café, and the aroma of home-cooked meals lets you know you're in for a real treat. Don't miss the signature ham and bean soup with a corn muffin, and save room for a milkshake or a slice of homemade pie. You'll feel like you're eating in the coolest museum in Iowa, thanks to interesting Lincoln Highway history exhibits, vintage photos and a 1939 Cadillac on display in the dining room. Too tired to keep driving? Book a room at the restored Colo Motel next door, a former cabin court that evolved in the 1940s into one of Iowa's first "modern" motels. "In this business, the best memories are the people you meet along the way," Joan Niland said.

Hobo House Becomes a Destination in Britt

Not everyone who travels through Iowa goes by automobile. The unforgettable characters who ride the rails and gather in the small northern Iowa town of Britt for the National Hobo Convention each summer know that there's one place not to be missed: Mary Jo's Hobo House. "These folks have lived the authentic hobo life, and many of them have become very close friends of mine," said Mary Jo Hughes, a Britt native who has owned and operated the Hobo House since 1994.

Filled with portraits and handwritten signatures, the walls of the Hobo House reflect the lives and unique stories of these hobos, from "Steam Train Maury" to "Connecticut Tootsie," whose personalities are just as colorful as their names. Mary Jo looks forward to reconnecting with her longtime friends over a good meal during the national convention, which was attracting 100 to 120 hobos each year when I first interviewed Mary Jo around 2011.

Back in the day, most hobos were single men riding the rails looking for work. As the trains slowed down near a station, the hobos would jump off

Iowa's rich agricultural heritage has greatly influenced the state's culinary heritage, from corn to beef to pork. Today, Iowa has nearly eighty-nine thousand farms, and more than 97 percent of these farms are owned by families. *Author's collection.*

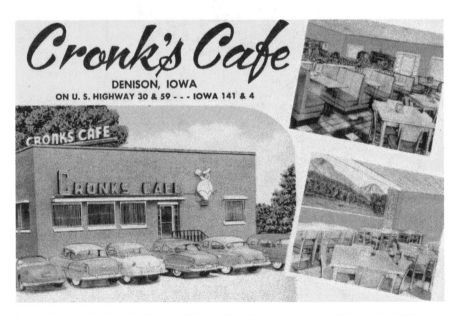

Located along the historic Lincoln Highway, Cronk's Café opened in Denison in 1929 and has been a favorite destination of travelers, truckers and presidential hopefuls for decades. *Author's collection.*

Parts of southern Iowa and northeast Iowa are home to Amish communities that reflect time-honored traditions as well as modern aspects of life, such as shopping at this Fareway grocery store in Cresco. *Author's collection.*

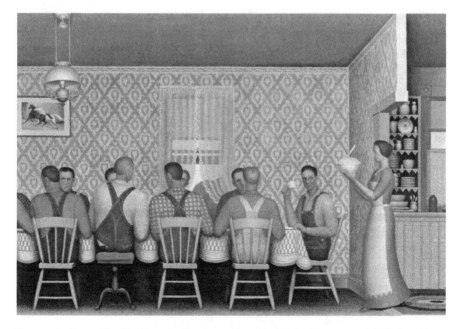

Iowa artist Grant Wood's *Dinner for Threshers*, painted in 1934, offers a nostalgic look at his memories of his family's eastern Iowa farm. At threshing time each summer, hardworking men would take a break from their labors in the field to enjoy a home-cooked meal in the family's farm home. *Courtesy of the Fine Arts Museums of San Francisco.*

Homemade pie, like this fine slice of cherry pie, is a time-honored tradition at family dinners, county fairs, fundraisers, RAGBRAI (Register's Annual Great Bicycle Ride Across Iowa) and more. *Author's collection.*

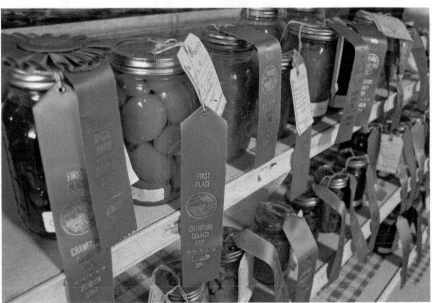

Iowa has ninety-nine counties, and thousands of Iowans of all ages put their culinary skills to the test each year at county fairs across the state. Ribbons and bragging rights are bestowed on the winners. *Author's collection.*

While Chris Soules may be best known as a former contestant on *The Bachelor* reality television series and *Dancing with the Stars*, the Arlington, Iowa farmer helped judge the National Pork Board's Pig Farmer of the Year contest in 2015 and has also made appearances at the Blue Ribbon Bacon Festival in Des Moines. *Author's collection.*

Deep-fried corn dogs are a classic food-on-a-stick at the legendary Iowa State Fair in Des Moines. They aren't just for kids, either. In 2012, presidential candidates Rick Perry and Michele Bachmann dined on corn dogs at the fair. *Courtesy of the Iowa State Fair.*

Dave Kitt, who owns Kitt's Meat Processing in the tiny Carroll County town of Dedham with his wife, Shawn, carries on the tradition of making Dedham bologna. The recipe for Dedham bologna, which is more than one hundred years old, is predominantly beef, with some pork included in the natural casings, all of which are tied by hand. *Author's collection.*

The nationally renowned Downtown Farmers' Market, which covers thirteen city blocks in Des Moines, is the oldest continuously operating farmers' market in America. *Courtesy of the Downtown Farmers' Market.*

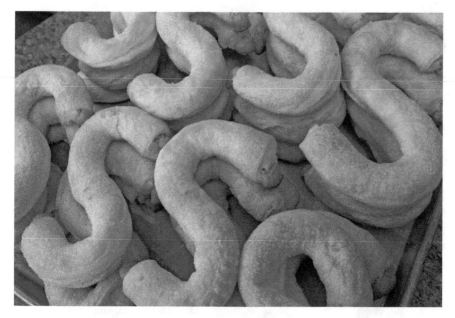

The famous pastries known as Dutch Letters are common in Dutch communities like Pella and Orange City. Traditionally, Dutch Letters were made only as a special treat for Sinterklaas Day (St. Nicholas Day) in early December. The pastries are typically shaped into an "S," for "Sinterklaas." Today, Dutch Letters are made year-round at Iowa bakeries known for their Dutch heritage. *Author's collection.*

Iowa has long been the nation's top pork-producing state. Ensuring animal well-being is important to pork producers like Erin Brenneman, who farms with her family near Washington, Iowa. *Courtesy of Erin Brenneman and Jen Madigan Photography.*

At the cemetery in Cascade, the recipe for "Mom's Christmas Cookies" is inscribed on the back of this gravestone honoring Maxine Menster, who passed away in 1994. Maxine's daughter, Jane Menster of rural Bernard, said the sugar cookie recipe serves as a reminder of her mother's love. "As the grandkids can attest, I never have a Christmas without these cookies," Jane said. *Courtesy of Jane Menster.*

What goes with chili? Cinnamon rolls, of course. No one knows exactly where the splendid idea of eating cinnamon rolls with chili began, but it has become an obsession for generations of schoolkids across Iowa. *Author's collection.*

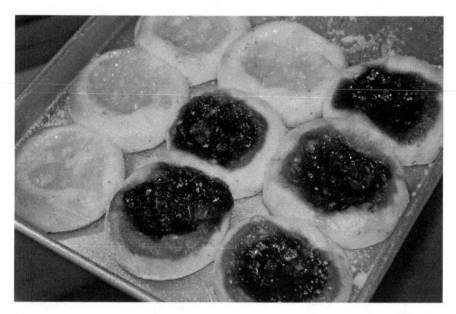

We can thank Czech/Bohemian immigrants for kolaches. While these tender pastries with sweetened fruit or cheese fillings are often associated with Cedar Rapids, they are also part of the culture in the Pocahontas area. The open-faced kolaches shown here are found in eastern Iowa, while Pocahontas-area cooks pull the corners of the dough over the filling before baking their kolaches. *Author's collection.*

Prosciutto and other artisan pork items produced by La Quercia in Norwalk are described as "a pig's leap into immortality." Herb Eckhouse, who founded La Quercia with his wife, Kathy, seeks out the best ingredients and crafts them by hand into foods that reflect the couple's appreciation for the bounty of Iowa. *Courtesy of La Quercia.*

When football season rolls around, fans of teams from the University of Iowa Hawkeyes to the Iowa State University Cyclones get fired up for tailgating. For Larry Sailer, a Franklin County farmer and pork industry ambassador, the main course at any tailgate feast naturally features pork, whether it's a smoked loin or grilled pork chops with Larry's famous marinade. *Author's collection.*

Since 1978, the Iowa Machine Shed restaurant has offered an authentic taste of Iowa farm cooking. Dedicated to the American farmer, the Machine Shed serves favorite dishes like this Stuffed Pork Loin with Sage Dressing. *Courtesy of the Iowa Machine Shed.*

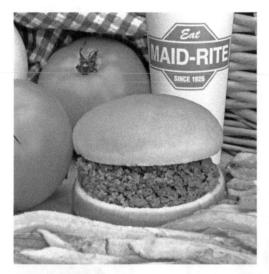

Call it the king of the loose-meat sandwiches. A tried-and-true Iowa classic for ninety years, the Maid-Rite dates back to 1926, and the Maid-Rite recipe has stayed the same from the beginning. *Courtesy of Maid-Rite.*

Pie and Iowa just go together. When Beth Howard (center), author of *Ms. American Pie: Buttery Good Pie Recipes and Bold Tales from the American Gothic House,* rented this iconic home in Eldon, Iowa, she periodically taught pie baking classes. Here I am (on the left) with my mom, Janet Dougherty, my friend Shannon Latham (second from right) and her mother, Shirley Fesenmeyer, celebrating our "victory pies" following an apple pie class in 2013. *Author's collection.*

Above: In 1947, Bob Piper and his wife, Ruth, of Chariton added high-quality, homemade candy to their product lineup at their corner grocery store. As it turns out, this candy (including hand-dipped chocolate turtles) would become Piper's claim to fame, noted current owner Jill Kerns (right) and her mother, Anne. *Author's collection.*

Left: The time-honored tradition of Pokey's Caramel Apples dates back to 1938, when Ottavio Pollastrini opened a candy kitchen in Carroll. Today, three generations of the family remain involved with the caramel apple business, including Betty Pollastrini; her daughter, Gina Nelson; Gina's husband, Dave; and the couple's daughter, Anna. *Author's collection.*

Since 1973, thousands of bicyclists have flocked to Iowa each summer for RAGBRAI (Register's Annual Great Bicycle Ride Across Iowa). The seven-day trek across the state from west to east averages 468 miles. The route includes many stops along the way, including this one in Fort Dodge in July 2015, where bicyclists could find food of all kinds, including the perennially popular homemade pie. *Author's collection.*

While Iowans love to celebrate with great food, some gatherings are much more than a party. Since 2002, Neal and Ginger Tribby have hosted a potluck at their home in St. Marys each year to remember the day America changed forever. "It's about appreciating our life, our freedom and all the blessings we have in America," said Ginger, who has hosted up to two hundred guests for the annual September 11 remembrance gathering. *Author's collection.*

"We really get into the sauce around here," joked Speed "The Sauceman" Herrig of Wall Lake, Iowa's beloved barbecue promoter and driving force behind Cookies Bar "B" "Q" for forty years. A founding member of the Iowa Barbecue Society, Speed cooked for former president George H.W. Bush during the World Pork Expo and uses his culinary skills to support Iowa charities. *Author's collection.*

Each time you purchase a bag of Sterzing's potato chips from Burlington, you're tasting a bit of Iowa history. Craig Smith and his team continue the tradition of producing potato chips the same way as the founder Barney Sterzing did in the 1930s. *Courtesy of Sterzing's Potato Chips.*

Nothing offers a taste of Iowa like fresh sweet corn. By July, old pickups of all types (like this one in Afton) become makeshift roadside stands where you can buy this delicacy by the dozen. *Author's collection.*

Iowans love their pork big and bold, and the famous breaded tenderloins are often as big as a dinner plate. Since 2003, the Iowa Pork Producers Association has hosted the Iowa's Best Tenderloin contest. The tenderloins from the Lucky Pig Pub & Grill (shown here) in Ogden won top honors in 2014. *Author's collection.*

Left: Scotcheroos aren't exclusive to Iowa, but these bake sale favorites are distinctive enough that they are associated with the state. Scotcheroos take rice krispie bars to a whole new level, thanks to peanut butter in the mix and a chocolate-butterscotch candy topping. *Author's collection.*

Right: In many Iowa communities, Jell-O remains a favorite menu item. While Strawberry Pretzel Squares would qualify as dessert in most places, many Iowans grew up calling this "Strawberry Pretzel Salad." Whatever you call it, it's tasty. *Author's collection.*

Annie the cow and Eric, her calf, are the much-loved "greeters" in front of the Anderson Erickson (AE) Dairy in Des Moines. At fourteen feet tall and 2,500 pounds of fiberglass, Annie has graced the intersection of Hubbell and University since 1966. Her five-foot, seven-inch calf has been by her side since 1977. In October 2007, Annie and Eric were involved in a cow caper. AE plant employees were startled by a loud crash and thud at 2:00 a.m. They discovered that Eric had been stolen and Annie had a large gash in her leg. Des Moines police quickly found Eric, whose leg had been broken, along with the vehicle used in the vandalism. Local news coverage triggered an outpouring of concern from area residents, including offers to repair the cow and calf. Annie and Eric were restored in time for the holidays that year. *Courtesy of Anderson Erickson Dairy.*

The Better Homes and Gardens Test Kitchen has been located in Des Moines since 1928. This image was taken sometime between 1967 and 1969 in the test kitchen. Carol Miller (left) was the assistant test kitchen director at the time, while Kay Cargil was the test kitchen home economist. *Courtesy of Meredith Corporation.*

The unforgettable characters who ride the rails and gather for the annual National Hobo Convention each summer in Britt know there's one place not to be missed: Mary Jo's Hobo House. Mary Jo Hughes preserves the photos and stories of friends from "Steam Train Maury" to "Redbird Express." *Author's collection.*

and find the nearby gathering places, called "hobo jungles." There, the men would visit and make mulligan stew, which included ground beef or pork, carrots, cabbage, celery, potatoes, barley, rice, ketchup, tomato paste, onions, salt, pepper and chili powder, according to a recipe from Britt, which has been hosting the hobos since 1900.

Today, the Hobo House is a popular destination during the National Hobo Convention, but it's also busy every day of the week with the locals. When I visited in 2011, Mary Jo opened for breakfast Monday through Friday at 5:30 a.m. and was usually met by six or seven early birds, including retired farmers. Then another group of men stopped by around 7:00 a.m., followed by the "coffee ladies" who arrived at 8:30 a.m. "It's fun because you become an extended family," Mary Jo told me.

Patrons love Mary Jo's famous Hobo Hashbrowns, sloppy joes and gigantic breaded pork tenderloins that are twice the size of the bun. They also look forward to the homemade casseroles and salads on the lunch buffet. "I just serve whatever strikes my fancy," said Mary Jo, who makes everything from meatloaf to tater-tot casserole.

It's not uncommon for Mary Jo to prepare some of her family's favorite dishes at the Hobo House. "Family means a lot to me, and I love being able to live and work in my hometown."

Macaroni Salad

Mary Jo often serves this classic salad at the Hobo House in Britt. This salad makes a large batch and is best if you make it a day ahead.

2 bags elbow macaroni, cooked
3 grated carrots
1 large green pepper, chopped
1 large onion, chopped
1 can Eagle brand milk
3 cups mayonnaise
¾ cup sugar
½ cup vinegar
salt and pepper, to taste

Combine all ingredients and refrigerate.

Supper Clubs Offer a Taste of Yesteryear

In the mid-twentieth century, many an Iowan grew up dining at the local supper club, an unmistakably authentic, midwestern phenomenon that lasted for decades in small towns across the state, especially in eastern Iowa. Far-flung locations (often at the edge of town) and distinctive décor gave each supper club a unique ambience. Guests could enjoy a relish tray and salad with creamy homemade dressing, the prelude to an enormous evening meal (complete with hearty classics like prime rib and your choice of potato), followed by an after-dinner drink. Popular options included old-school ice cream drinks spiked with liquor, from Grasshoppers to Pink Squirrels.

Never pretentious, Iowa supper clubs were family-run, time-honored social gathering spots where countless families celebrated anniversaries,

While the Pink Elephant Supper Club in Marquette is gone, Pinky the Elephant still stands outside the Lady Luck Casino in Marquette, overlooking the mighty Mississippi River. Pinky, which was originally created for a Republican political convention in the 1960s, stole the show in the late 1970s when fun-loving Democrats loaded the elephant onto a pontoon boat, and Pinky "water-skied" down the river to visit President Jimmy Carter. *Author's collection.*

birthdays and more. While supper clubs have been fading from the landscape, especially in small towns, some still remain, including the Lighthouse Inn Supper Club in Cedar Rapids. Built in 1912, the Lighthouse Inn became a common stop during Prohibition for Chicago mobsters looking to "beat the heat" until things cooled off back in the Windy City. (Yes, Al Capone dined here, as did John Dillinger.) While the gangsters are gone, the promise of a relaxing evening with great food remains.

Soul Food: Lanesboro Church Dinner Attracts Hundreds

Family, food and community are a natural fit in small towns across Iowa, especially when it comes to church suppers. From home-cooked chicken noodle dinners in October to the annual beef dinner in March, the

Lanesboro United Methodist Church has become famous in west-central Iowa for down-home meals full of local flavor. "Good food is a tradition here," said Jan Snyder, who has co-chaired the annual chicken noodle dinner. "Some years we run out of food after serving three hundred people in the church basement dining room and selling one hundred carryout dinners."

It's no wonder the dinners at this small Carroll County church in Lanesboro (population 121) have become such a hit. In recent years, nearly 50 church members and volunteers ranging in age from six to ninety have helped serve heaping portions of homemade chicken and noodles (made from more than 100 pounds of chicken), real mashed potatoes (prepared with 150 pounds of potatoes), made-from-scratch biscuits, a fabulous salad bar filled with more than thirty salads and a dessert bar featuring more than forty homemade pies, angel food cakes and more. "This is the real deal," said Sally Brown, who noted that harvest crews are welcome.

While the beef dinners and chicken noodle dinners date back about thirty years, they build on a church culinary tradition that started decades before, said Snyder, who recalled that members hosted fried chicken dinners about fifty years ago.

Every year, the Lanesboro church dinners continue to attract longtime customers, as well as new guests, from Carroll, Calhoun, Sac, Greene and Webster Counties. "While it takes a lot of people and a lot of work to host the dinners, the fellowship is worth a lot," added Snyder, who noted that the events typically raise several thousand dollars. The income also allows members to buy extra things for the church, from new flooring to items for the puppet ministry, which uses puppets to entertain audiences of all ages while teaching about the Bible.

While home-cooked church suppers across Iowa are slowly becoming a thing of the past as longtime church members age and younger families juggle jam-packed work and school schedules, you can still find excellent church suppers in many small towns if you know where to look. The price is right, and you won't go away hungry.

Copper Pennies (Marinated Carrots)

This recipe from Jan Snyder is served at the both the chicken noodle dinner in October and the beef dinner in March.

2 pounds sliced carrots
1 can tomato soup
1 small onion, chopped
½ cup vegetable oil
1 teaspoon prepared mustard
1 small pepper, chopped fine
¾ cup vinegar
½ cup sugar

Cook carrots; drain and cool. Mix remaining ingredients together and pour over carrots. Mix well and refrigerate. The flavor improves with time.

The Barrel Keeps the 1950s Alive in Clear Lake

While some Iowa towns like Lanesboro are off the beaten path, others have gained fame worldwide, like Clear Lake, which offers a taste of the 1950s. Clear Lake is the home of the renowned Surf Ballroom, a rock-and-roll hotspot in the 1950s that became a must-play venue on the performance circuit. This was the case on February 2, 1959, for the famed Winter Dance Party featuring Buddy Holly, Ritchie Valens and J.P. "the Big Bopper" Richardson. It was this fateful show that made the most lasting mark on the Surf Ballroom.

The stars played before an estimated 1,100 enthusiastic fans before heading to their next gig in Moorhead, Minnesota. Tragically, the plane carrying Holly, Valens, the Big Bopper and their pilot, Roger Peterson, crashed early the next morning near Clear Lake. The death of the three stars is often referred to as "the Day the Music Died."

The Surf has lived on, however, and so has another Clear Lake icon from the 1950s: The Barrel Drive-In. Opened in 1958, the classic drive-in is known throughout north Iowa for its famous roasted chicken (symbolized by a larger-than-life Cooper the Rooster by the east driveway), homemade root beer and homemade salad dressings. While the classic restaurant was in

danger of closing a few years ago, Seth Thackery, who began working there as a teenager, saved The Barrel from demolition.

Unique elements of The Barrel hint at its rock-and-roll roots, from Elvis songs like "Jailhouse Rock" on the radio to a now-empty room on top of the drive-in where local deejays once broadcast hit songs on KRIB. While saving The Barrel has been a struggle, local business leaders and community members have stepped up to lend business coaching and financial support. It's encouraging to Seth, who has poured his heart and soul into the restaurant. "We have a great community, and we're proud to carry on this legacy of the 1950s rock-and-roll era," he said.

SMALL TOWN, HIGH SOCIETY AT MALLORY'S CASTLE

While small Iowa towns tend to embody a cross-section of middle America today, the wealth that was evident in many small towns in the nineteenth century reflected the opportunity that enriched savvy entrepreneurs and businessmen on the prairie.

Consider Mallory's Castle—named Ilion by its builder—which was constructed in the southern Iowa town of Chariton in 1879–81. This legendary Lucas County home provided the perfect setting for grand parties, afternoon teas and prestigious gatherings that redefined the social life of this county seat town. It also reflected the rise and fall of one of the grandest families Chariton has ever known.

The home was the dream of Smith H. Mallory and his wife, Annie, who arrived with their daughter, Jessie, in Chariton during 1867 with the first trains. Smith Mallory had just begun to amass a fortune constructing rail lines and bridges. Mallory also built one of southern Iowa's most powerful banks, became the region's most innovative agriculturalist on his one-thousand-acre Brook Farm and played a role in virtually every other county enterprise, including plow manufacturing.

Brook Farm had contracts with the railroad to supply the dining cars of passenger trains passing through the area, as well as the Depot Hotel restaurant in Chariton. Milk, eggs and fruit from the farm were sold commercially in Chariton and beyond.

Ilion and Brook Farm were largely self-sufficient with food. An eighty-acre orchard was planted even before Ilion was built. There were huge truck gardens and cool-storage caves for produce and fruit. Cattle, hogs and

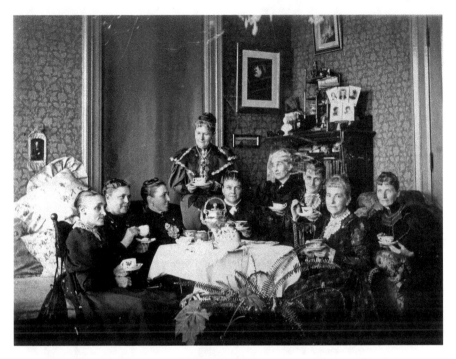

Annie Ogden Mallory (Mrs. Smith Henderson Mallory), shown here seated in the center behind the teapot, hosts a party in the southeast parlor of her family's grand home in Chariton. Mallory's Castle, named Ilion by the family, was built in about 1880 but was torn down by 1955 and replaced by a subdivision. *Courtesy of Lucas County Historical Society.*

sheep were bred, raised and harvested. A commercial dairy and egg laying operation also were part of Brook Farm during its history.

Smith and Annie Mallory were lavish entertainers in Chariton, where the population had grown steadily to four thousand people by 1900. Their stately home northwest of the town square was designed to accommodate a crowd. The dining room at Ilion seated twelve comfortably, but much larger groups were frequently invited to the home.

Jessie Mallory, a talented musician, often provided musical entertainment in the spacious southwest parlor. On June 9, 1886, about seventy guests were welcomed at the home's formal front entrance to attend the wedding of Jessie and her husband, Deming Thayer.

The Mallory family relied on hired girls to assist with the many household duties at Ilion. The family also had a designated cook at times. Ilion included a staircase in the kitchen wing for servants. While there were a few rooms on the second floor of the kitchen wing for servants, most of these staff members seem to have lived elsewhere in Chariton with their families, noted

Piper's Grocery and Candies has offered a taste of history in Chariton for decades. Opened in 1903, the shop has been a fixture on the northeast corner of the town square since 1905. Not only did farmers trade their wares for groceries, but groceries were also delivered several times a day to area homes in years past. "Huckster wagons" also hauled supplies from Piper's to the thriving mining communities in the area. *Author's collection.*

local historian Frank D. Myers. Hired staff who came from local farms typically boarded nearby. Longtime employees Henry and Emma Stroud, who worked for the Mallory family from the 1870s until 1909, lived in a cottage on the estate and handled whatever work needed to be done.

Smith Mallory's legacy seemed assured by the time he died during 1903 of stomach cancer and was buried in the Chariton Cemetery. "But then it all came tumbling down during 1907 when the suicide by morphine of trusted Mallory associate and First National Bank Manager Frank Crocker revealed that he had gutted and dissipated bank assets," noted Myers in his popular blog "The Lucas Countyan." "It was Lucas County's greatest financial calamity until the Great Depression."

In the aftermath, all Mallory assets in Lucas County were turned over to the government to cover bank losses after a long and bitter court fight involving the widow, Annie, and daughter, Jessie. The women fled to Florida, taking Ilion's contents with them, along with Jessie's still-substantial fortune, sheltered from creditors.

Ilion, which had been one of the most elaborate houses ever built in Lucas County, eventually fell into disrepair. The doors were thrown open for one last party in April 1955, when Chariton Rotarians brought the old house to life again briefly so anyone who was interested could tour Mallory's Castle. Thieves had stolen a chandelier or two and a few other fixtures beforehand, but it made little difference. The once-grand mansion was soon torn down to make way for a housing development. Now only memories, a Chariton street named Ilion Avenue and a few photographs of high society in a small town remain.

Other pieces of Chariton's history continue to add flavor to small-town life, however, including Piper's Grocery and Candies. Opened in 1903, the shop has been located on the northeast corner of the town square since 1905. From all accounts, Piper's was considered the premier grocery store in town. Not only did farmers trade their wares for groceries, but groceries were also delivered several times a day to area homes. "Huckster wagons" also hauled supplies from Piper's to the thriving mining communities in the area.

By 1947, when Bob Piper and his wife, Ruth, ran the store, they had added high-quality candy. As it turns out, delicious homemade candy would become Piper's claim to fame. The shop is known for its handmade, hollow chocolate Easter eggs, with the biggest ones weighing five pounds after being filled with chocolate turtles and other homemade candies. "Bob and Ruth developed top-notch candy making skills, and we still use the same recipes and techniques they used all those years ago," said owner Jill Kerns. "Why mess with perfection?"

CITY STYLE AND FINE DINING

While Iowa's culinary history is interwoven with small towns, it's accented with tales of high society and fine dining in the state's larger cities and metropolitan areas. In an earlier era, the wealth and standard of living enjoyed by some of Iowa's leading families were almost unimaginable. In other cases, the refinements of urban life extended to everyone, not just the privileged few.

BACK STAIRS AT BRUCEMORE: SERVANT LIFE IN EARLY TWENTIETH-CENTURY IOWA

In the late nineteenth and early twentieth centuries, many live-in domestic servants worked for wealthy and even middle-class American families. Such was the case for the families who lived at the Brucemore estate in Cedar Rapids, where servants helped with cooking and other tasks in the fifteen-thousand-square-foot, twenty-one-room mansion.

Brucemore's history reflected the power of Iowa's growing agribusiness sector, the immigrants who came to Iowa to seek new opportunities, modern food processing technologies and the expansion of railroads that brought an economic boom to the Midwest. Brucemore's story is also intertwined with the servants whose labor granted their employers a privileged lifestyle.

Caroline Soutter Sinclair, the estate's first owner, built the mansion between 1884 and 1886 as a home for her six children. The Sinclair family's

meat processing plant made the home possible. Caroline's late husband, T.M. Sinclair, had opened the Sinclair & Company plant in Cedar Rapids in the heart of downtown. Railroads that connected Cedar Rapids to Chicago helped secure the venture's success. By the mid-1870s, Sinclair & Company had become one of the largest employers in the region. It also became one of the first plants in the country to harvest river ice for ice refrigeration, which prevented meat from spoiling. Meatpacking became a year-round business, thanks in part to the plant's proximity to the Cedar River.

Sinclair & Company, which became the fourth-largest packing plant in the world by 1878, processed an average of three thousand hogs per day during the winter and one thousand per day during the summer. Tragedy struck in 1881, however, when T.M. Sinclair died after falling into an elevator shaft while inspecting the plant.

In 1884, T.M.'s wife, Caroline, began construction of a three-story, Queen Anne–style mansion on ten acres of land. Located two miles from downtown Cedar Rapids, the $55,000 home made quite an impression in 1880s Cedar Rapids. It was described by a local newspaper as "the grandest house west of Chicago."

Like many large homes built in the 1880s, the mansion had clearly defined areas for servants, including a separate entrance, dining area and set of stairs. Servants could become virtually invisible, as their work and living spaces could be closed off from the family's side of the house. Two rooms on the mansion's third floor served as servant bedrooms.

By 1906, Caroline traded homes with George and Irene Douglas, who had a profound influence on the industrial and cultural development of Cedar Rapids. The family's industries, Douglas & Company (which included a corn starch and corn oil business) and Quaker Oats, provided employment for the city's residents and an income that allowed the Douglas family to purchase and run the estate they renamed Brucemore (a combination of George's middle name and an allusion to the moors of Scotland).

The Douglas family made Brucemore a lively home with all the benefits of a country estate. They tripled the property size and added a guesthouse, greenhouse, paved tennis court, pool, pond, formal garden, servants' duplex and more. Domestic servants were integral to the decorum and functionality of Brucemore.

In Cedar Rapids at that time, a small number of families had two servants, while an exclusive group hired three or more servants. The well-heeled Douglases, a family of five, employed one or two maids, a butler, a cook, a nanny, a coachman or chauffeur and a head gardener

who supervised a crew of groundskeepers. (Although the Brucemore staff was quite sophisticated for Cedar Rapids, it was small compared to those of the Douglas family's peers in other areas of the nation, including the South and Northeast United States.)

During the years that the Douglas family made Brucemore their home from 1906 to 1937, ten or more people maintained the mansion and grounds at any given time. Freed from the routines of home maintenance and housework, the Douglas family could pursue hobbies, artistic projects and community service, such as George and Irene's roles as trustees of Coe College in Cedar Rapids.

Servants working for the Douglases and other families across the country were expected to follow a strictly defined behavioral code and standard of work. They were required to be neatly dressed and polite and maintain a calm disposition at all times. Workdays were long, as hired help would wake up before the family to clean the main rooms of the home, prepare breakfast and serve family members as soon as they awoke. A servant's day would continue until the family retired for the night.

Due to the long hours, housing was provided for essential staff. Servants working inside the house (including the maids, butler and cook) generally lived on the third floor of the mansion. A Swedish cook, Mabel Seay, took charge of the kitchen and oversaw the elaborate meals that were part of the formal dinners at Brucemore. Additional maids most likely assisted her with the more tedious aspects of food preparation, as well as cleaning the mountain of dishes that resulted from a formal meal.

Those days wouldn't last forever. The Douglases lived in a time when changes in society and culture made hiring, managing and keeping servants more difficult. Although domestic service often paid better than factory or department store work, the lack of personal freedom, unpredictable and long hours and social stigma discouraged women from taking these positions.

As a result, employers frequently turned to immigrants and minority populations as a source of help. In Linn County, Iowa, many Bohemian and German immigrants, along with American-born girls, worked as servants. By the 1920s, however, the servant pool had become even more limited due to World War I and immigration restrictions.

While middle-class housewives stopped hiring live-in servants in favor of new household appliances and day workers, wealthy families continued to hire live-in servants to illustrate social status and maintain their larger homes and estates.

Nevertheless, the servant staff at Brucemore would become part of the past. The Douglases' daughter, Margaret, and her husband, Howard Hall, were the last residents to live at the Brucemore mansion. In 1981, Margaret left her family estate to the National Trust for Historic Preservation for the benefit of her community. It exists today as a museum and community cultural center that showcases the history of Iowa business and social leaders who helped shape Cedar Rapids, eastern Iowa and the Midwest.

TERRACE HILL: THE "CASTLE AMONG CORN ROWS"

Elegant and stately, one of Iowa's iconic mansions has always been a home during its extensive history. Terrace Hill has played a unique role in Des Moines history for decades and has added a tasteful element to Iowa's culinary history.

Des Moines, which became Iowa's capital city in 1857, exploded in size and importance after the Civil War. As the capital city grew, its first millionaire, Benjamin Franklin Allen, began working on his dream home. In 1866, he hired renowned Chicago-based architect William W. Boyington to shape his vision into a reality. Lavish praise for the architect's plans appeared in the April 28, 1867 *Daily State Register*, proclaiming that the residence and its grounds would be "equal to anything west of New York." When Terrace Hill was finished in 1869, the final cost of the buildings and grounds reached $400,000.

Benjamin and Arathusa Allen opened Terrace Hill to their friends on January 29, 1869, on their fifteenth wedding anniversary. More than one thousand invitations were mailed, some to New York City. Chicago was represented by at least a dozen guests, including architect William Boyington. Among the Iowa dignitaries were Governor Samuel Merrill, Congressman-elect Frank Palmer and judges from the state Supreme Court, according to the book *A Taste of Terrace Hill*.

Guests were awed by the palatial Second Empire–style residence, which included fifteen-foot ceilings, arched doorways and custom-made furniture, mirrors, carpets, statues and more. The food was served at 10:00 p.m. in the dining room. The meal had been prepared by John Wright, who was brought in from the Opera House Restaurant in Chicago. There were two fruitcakes weighing twenty-five pounds each, ice cream molded into the shape of George Washington, oysters, turkey and other meats. Flowers were

everywhere. The cost for just the bouquet at the center of the long dining room table was $700.

This gala evening was echoed on June 9, 1979, with an elegant dinner dance sponsored by the Terrace Hill Society, with proceeds going toward the restoration of Terrace Hill. Many of the details of the 1869 gala were adapted, such as the invitation design and portions of the menu and décor. The 1979 menu included cold lobster mousse in flaky pastry shells, brie cheese served with grapes and strawberries, turkey breast, sliced beef tenderloin, rack of lamb, marinated vegetables, potato nests filled with peas a la bonne femme, decorated Victorian lady cakes, strawberry tarts and whole wheels of Stilton cheese. This Vegetables Vinaigrette recipe offers a taste of Terrace Hill.

Vegetables Vinaigrette

1 tablespoon Dijon mustard
3 tablespoons white vinegar
3 tablespoons olive oil
¼ teaspoon dried basil
salt and pepper, to taste
2 shallots, finely chopped
fresh vegetables of your choice

Whisk mustard, vinegar, olive oil, basil, salt, pepper and shallots together. Set aside. Cook fresh vegetables to the just-crisp stage. Drain and cool quickly in cold water. Marinate each type of vegetable separately in vinaigrette. Refrigerate overnight before serving.

Not long after Allen built his "castle among corn rows," he lost his fortune and sold the mansion for $60,000 in 1884 to Frederick Marion Hubbell, a prominent Des Moines real estate, railroad and insurance magnate. The 1885 census showed that the residents of Terrace Hill included F.M. Hubbell; his wife, Frances; and their children, Frederick, Beulah and Grover, plus three female domestics and three male laborers.

Hubbell added many of Terrace Hill's most well-known features, including the magnificent stained-glass window and stunning crystal chandelier. The

Hubbell family made Terrace Hill the setting for many social and historical events, including a party in 1895 to celebrate the fortieth anniversary of Mr. Hubbell's arrival in Des Moines (known as Fort Des Moines in the early years). He shared the occasion with other Des Moines pioneers, including Hoyt Sherman and James Savery. Hubbell's diary for that day noted, "Dinner at 7. Dispersed at 10 p.m. Good time, they said. Wanted me to send for them at the end of another 40 years."

Every year, Mr. Hubbell hosted a dinner party to entertain members of the Des Moines City Council. By some accounts, any differences of opinion were forgotten at the dinners, which were sometimes followed by poker games. The Hubbells also hosted a Fourth of July dinner party each summer, followed by fireworks. Neighbors would watch the display from the streets.

In 1897, the Hubbells opened Terrace Hill to five hundred guests who had gathered in Des Moines for a women's suffrage convention. Some of America's leading suffragettes attended the gala. A description of the party noted that guests were led to the dining room, where coffee and confections were served from a table beautifully decorated in yellow and blue. The centerpiece consisted of an immense jardinière of yellow jonquils resting on yellow embroidered linen and accented by lit white tapers in tall candelabra.

Terrace Hill reflected luxurious city living in the heart of Iowa. In the 1890s, the ornate dining room featured elaborately stenciled ceilings, a massive built-in buffet, a chandelier over the large dining room table, wallpaper with rich detailing and ornate shelving over the marble fireplace. A door from the dining room opened into a large butler's pantry equipped with a sink, icebox, warming stove, serving counter and dumbwaiter used to carry prepared food from the ground-floor kitchen (with an adjacent servants' dining area) to the first-floor dining room.

Despite the numerous parties and rich meals served at Terrace Hill, F.M. Hubbell often followed a vegetarian diet and regarded overeating as one of man's deadliest foes. He credited his good health and long life to a light diet.

In 1899, the exquisite mansion provided a dramatic setting for Beulah Hubbell's lavish marriage to Swedish count Carl Wachtmeister, whom she had met in Chicago at the Swedish consulate. The event was so opulent it was called the "wedding of the century" and rivaled the Allens' 1869 grandiose housewarming party. The seven hundred guests included nobility from several European nations, members of the Des Moines aristocracy and guests from Chicago and Washington, D.C. The bridal party assembled on the landing of the grand staircase, and the vows were said under the magnificent parlor chandelier. The bride wore a white

satin brocade gown, which she had worn when presented to royalty at the court of St. James.

After Frances Hubbell passed away in 1924, the Hubbell's youngest son, Grover; his wife, Anna; and their three daughters moved to Terrace Hill with the widowed F.M. Hubbell. Helen Ann Hubbell Ingham (a great-niece of Grover and Anna) recalled the elaborate family dinners held at Terrace Hill at Thanksgiving and Christmas. The holidays included long, beautifully decorated tables filled with food, flowers, crystal wine service for each course, candlelight and a gift at each child's place. Christmas celebrations at Terrace Hill included roast suckling pig or a feast of roast goose raised on the grounds.

"Maids attired in snappy black dresses with perky white aprons and pleated white headbands served us soup, salad, wines, dinner and dessert," noted Ingham in *A Taste of Terrace Hill*. "There was no need for parental coaching, for we children sensed that this was an occasion for careful eating and best manners."

Memories later recalled by Elmer Nelson, who served as chauffeur, butler, gardener and more for the Hubbells for thirty-three years, made it seem as if there were always parties at Terrace Hill in the 1920s and 1930s. "The summer was our favorite, for the Hubbells had several hundred guests, and they were served from tables that were gorgeous, with ice images carved with colored lights below them for centerpieces," according to Nelson, whose stories are preserved in *A Taste of Terrace Hill*. "They were a sight to see. The Hubbells would bring in portable dance floors, hire orchestras and dance until the wee hours of the morning."

The Hubbell family lived in Terrace Hill until Grover's death in 1956. After Anna Hubbell disbursed Terrace Hill's furnishings to family members and moved to an apartment, none of the Hubbell heirs wished to make the mansion their home. Values and attitudes had changed, and large homes were considered impractical for modern family use. Terrace Hill's future was jeopardized in a way it never had been before.

In 1971, the Hubbell family graciously donated the home to the State of Iowa to be used as the official residence of Iowa's governor and first family. The first floor is used for receptions and parties and can be toured by the public. The second floor includes guest bedrooms and offices. The third floor is the official residence of the governor.

In addition to being open to the public for tours, Terrace Hill also hosts various events for the public throughout the year, including the popular "Tea and Talk" lecture series, holiday teas and more. This remarkable home remains a treasure not only for Des Moines but also for the people of Iowa.

A TASTE OF ELEGANCE AT THE YOUNKERS TEA ROOM

Elegance. Grandeur. Sophistication. All defined the iconic Younkers Tea Room that graced downtown Des Moines for nearly one hundred years. While the Younkers Tea Room closed in 2005, glorious memories of the stunning décor, fine dining and Younkers' famous rarebit burgers, chicken salad, spinach salad, sticky rolls and more live on.

"The Tea Room was the most elegant place I'd ever been—like a stateroom from Buckingham Palace magically transported to the Middle West of America," recalled Des Moines native and best-selling author Bill Bryson, whose book *The Life and Times of the Thunderbolt Kid* details a visit to the Younkers Tea Room with his mother and sister. "Everything about it was starched and classy and calm."

When it opened in 1913, the Younkers Tea Room reflected not only a pivotal era of societal change in America but also a new chapter of Iowa's

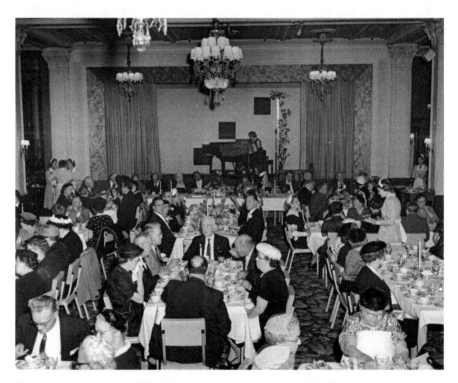

Elegance, grandeur and sophistication defined the iconic Younkers Tea Room, which opened in downtown Des Moines in 1913 and closed in 2005. This photo shows a dinner for Younkers' 20-Year Club members in the Tea Room on October 9, 1956. *Courtesy of the State Historical Society of Iowa, Des Moines.*

culinary heritage influenced by Jewish immigrants. Iowa's first Jewish settlers began arriving on the frontier in 1833 at the pioneer town of Dubuque. In the 1840s and 1850s, many of the early Jewish arrivals in Iowa peddled household goods to rural homes. They found that Iowa farmers, isolated by the young state's notoriously muddy roads, gladly welcomed Jewish peddlers with much-needed supplies.

Some Jewish merchants opened shops in small towns. Lipman, Samuel and Marcus Younker opened their first dry goods store in the southeast Iowa town of Keokuk in 1856. After the economy plummeted in the Panic of 1857, however, many of the small towns where Jewish immigrants had started businesses were floundering. Growing cities like the new state capital of Des Moines appeared to offer more attractive business opportunities.

In 1874, the Younker brothers' younger sibling, Herman, opened a branch of the Keokuk store in Des Moines. The Younker brothers closed their Keokuk store in 1879 and moved their business and inventory to Des Moines. In 1899, the Younker brothers relocated the store to its widely known location at Seventh Street and Walnut Avenue in downtown Des Moines.

By the time the Younkers Tea Room opened its doors in 1913, the entrepreneurial Younker brothers had seized a trend that began gaining momentum in the late nineteenth century and early twentieth century. Marshall Field's in Chicago was the first department store to open its own tearoom in 1890. Like other department store tearooms in American cities, the Younkers Tea Room provided not only fine dining but also a unique venue to attract more customers and advertise the store's merchandise. The Younkers Tea Room, which was located on the fifth floor of the department store by 1925, gave women a public gathering place where they were welcomed, as compared to the men-only clubs, bars and pool halls of the era.

Younkers became *the* place to shop for everything from bedding to clothing to wedding gifts, and the Tea Room quickly became one of Des Moines's showplaces. In an era when people dressed up to go shopping downtown, Iowans often made a day out of a trip to Younkers and looked forward to lunch at the Younkers Tea Room. Guests often enjoyed more than just a dining experience. In the 1920s, for example, Younkers' store employees would model furs and fine jewelry at the Younkers Tea Room.

Not only did the upscale Younkers Tea Room create an inviting, relaxing escape from the hustle and bustle of daily life, but it also became a popular location for wedding receptions, bridal showers, fundraisers and other events.

In addition, the Younkers Tea Room hosted many civic-minded groups in the Greater Des Moines area, ranging from the Des Moines Women's Club to the Junior League. In the late 1990s and early 2000s, the Tea Room hosted "Let's DU Lunch," a series of lunch-and-learn events sponsored by Drake University for local business professionals.

Throughout its history, the Younkers Tea Room remained one of the premier places to dine in Des Moines. The room was elegant in every sense of the word, with its sumptuous French provincial and Victorian décor, plush floral carpeting, rich woodwork, high ceilings, sparkling chandeliers, dramatic columns and floor-to-ceiling drapes on the large, expansive French windows that offered diners a spectacular view of the city.

The Tea Room's professional waitstaff was known for being courteous, friendly and attentive. "It almost made you feel like family," recalled one Tea Room guest. Attention to detail was also evident on every table, which showcased starched, white linen tablecloths, cloth napkins, chilled pats of butter and ice water served in crystal goblets. Even the waiting area for the Younkers Tea Room was elegant, with its spacious lobby and well-appointed sofas and chairs near the vintage elevator that delivered guests to the fifth floor.

While it was gorgeous during the day, the Younkers Tea Room was even more impressive in the evening, by some accounts. Years ago, an evening out meant dinner and dancing with a live band playing the hottest new songs. With the dinner check, guests could receive two tickets to a double feature at one of the downtown movie theaters, such as the Paramount, the Des Moines or the Orpheum.

The Younkers Tea Room wasn't just for the elite. For decades, it was known for excellent food at quite reasonable prices. Men, women and children were all welcome at the Younkers Tea Room. Even children knew that this was someplace special. After the meal, the staff would bring around a box filled with toys, from plastic dolls to small cars, wrapped in tissue paper. For many children, these parting gifts were the highlight of their visit.

Many people also remember the spectacular Christmas tree, lavish holiday window decorations and "Breakfast with Santa" that were all part of the Younkers experience each December. After families completed their Christmas shopping at Younkers, they often stopped by the Tea Room for lunch. During the holidays, guests could often sample a wide array of treats from an impressive dessert table.

Throughout the year, the refined atmosphere of the Younkers Tea Room set the mood for pleasant conversation among friends and family

amid the clinking of china dishes and crystal glasses, as soft background music emanated from the grand piano on the Tea Room's stage. A young Drake University student name Roger Williams sometimes performed at the Younkers Tea Room. This Des Moines native became one of America's most popular pianists and was best known for his instrumental rendition of "Autumn Leaves," which became a smash hit in 1955.

While formal attire was not required, people certainly didn't wear jeans and T-shirts to the Younkers Tea Room, opting instead for their Sunday best. For many years, women wore dresses, hats and gloves, along with matching handbags and shoes. "You wanted to give the tea room the respect it deserved," recalled one woman who spoke with Emily Cokeley, an Iowa State University graduate student who documented the rich history of the Younkers Tea Room in her thesis. "You felt important when you went there."

Adults and children displayed their best manners at the Younkers Tea Room, where proper etiquette was expected of guests, regardless of one's age. The Tea Room also provided a unique learning experience for local teenagers who were selected to participate in Younkers' Teen Board. Two students, one boy and one girl, were selected from each Des Moines–area high school based on their leadership qualities, scholastic standing and personal recommendations from school administrators. Part of the Teen Board's duties involved modeling the latest fashions on Saturdays at noon at the Younkers Tea Room.

By the 1970s and 1980s, fashion shows at the Younkers Tea Room also included legendary designers like Roy Halston Frowick, a Des Moines native. At the height of his fame, Halston visited the Younkers Tea Room in the early 1970s for a fashion show featuring his famous ultra-suede shirt-dress. In addition to well-known fashion designers, celebrities also visited the Younkers Tea Room from time to time, including Miss America winners and actress Jane Seymour, who promoted a line of dinnerware she created.

Besides the fashion shows and other special events held at the Tea Room, the downtown Younkers department store celebrated Festival Europa, which showcased cultural and culinary delights from England to Italy. The Younkers' buying team would purchase merchandise from the featured country for each Festival Europa and highlight the items in the downtown Des Moines store. Activities during Festival Europa included wine tasting, foods from the themed country and cooking classes. The fun events proved popular and attracted many people to the Younkers Tea Room for a number of years.

Each March, teenaged girls from small towns and farms across Iowa also got to experience the grandeur of the Younkers Tea Room if their high school

basketball team played in the state girls' six-on-six basketball tournaments at Veterans' Memorial Auditorium in Des Moines. The Younkers Tea Room invited all the girls playing in the tournament for a breakfast and style show as part of their big week in Des Moines, a truly magical time for talented small-town girls with big-time dreams.

During the workweek, the Younkers Tea Room became a great equalizer as women entered the workforce in downtown Des Moines in greater numbers in the 1960s and 1970s. While women were not allowed in men's private clubs in the heart of the city, women who worked downtown were frequent guests at the Younkers Tea Room.

Although Younkers remained a popular back-to-school and holiday shopping destination for Iowa families for decades, the beginning of the end for the downtown Younkers department store and the famed Younkers Tea Room started with the era of the shopping mall. While many customers remained loyal to the downtown Younkers store, the opening of Merle Hay Mall in Des Moines in 1959, followed by Valley West Mall in West Des Moines in 1975, decreased traffic at the downtown Younkers location. The malls were closer to the Des Moines metro's growing suburbs and offered more convenience.

By then, the Younkers Tea Room had already far outlasted many of its early twentieth-century contemporaries. After World War II ended, for example, most tearooms, apart from those in department stores, had ceased to thrive and were considered the "old lady of the restaurant industry," according to author Jan Whitaker, who has documented a social history of the tearoom in America. By the late 1980s and 1990s, societal trends were proving too much for the Younkers Tea Room, which had become one of the last of these elegant relics in the United States. The heyday of downtown shopping had waned, casual Fridays were changing the workplace and many people weren't interested in dressing up just for a meal.

Changes in the corporate structure of Younkers, which had been bought out by Saks Inc., also led to the demise of the Younkers Tea Room, which closed permanently in 2005. While there was hope for a revival when developers purchased the former Younkers building in 2012 and began renovating the property, those dreams went up in flames on March 29, 2014, when a catastrophic fire destroyed the building.

While the era of the Younkers Tea Room was over, the legacy of this Iowa icon is preserved in cookbooks like *Holiday Celebrations with Recipes from Younkers* and the social networking site Facebook, which has nearly 1,200 members in a group called "Memories of a Younkers Tea Room." Variations of the

menu specialties that countless Iowans enjoyed for decades at the Younkers Tea Room, including rarebit burgers (hamburgers with cheese sauce poured on top), can still be found at various central Iowa restaurants like the Ankeny Diner, whose rarebit burger features spicy cheddar cheese sauce, served open-faced.

Christopher's Restaurant, which has been a Des Moines tradition for more than fifty years, also features its modern interpretation of the rarebit burger, which is described on the menu as a "perfectly prepared hamburger patty covered with authentic rarebit sauce." In the spring of 2014, Christopher's also created a limited-time menu featuring favorite foods from the Younkers Tea Room, including Younkers Chicken Salad. Both the memories and the unforgettable flavors of the spectacular Younkers Tea Room live on.

Tea Room Chicken Salad

3 cups diced, cooked chicken thighs
1 cup chopped celery
¼ cup chopped onion
¼ cup shelled sunflower seeds
1 cup ranch salad dressing
1 teaspoon celery salt
½ teaspoon dried minced garlic
salt and black pepper (optional)

In a large bowl combine chicken, celery, onion and sunflower seeds. For dressing, in a small bowl stir together salad dressing, celery salt and garlic. If desired, season to taste with salt and black pepper. Pour dressing over chicken mixture; toss to mix well. Cover and chill for 1 hour. Makes 6 servings.

Younkers Rarebit Burgers

To make Younkers' popular rarebit burgers, cook 8 hamburger patties to 160 degrees until no pink remains. Place each burger in a toasted hamburger bun. Spoon about ¼ cup of rarebit sauce over each bun. Serve immediately.

Tea Room Rarebit Sauce

⅓ cup vegetable oil

⅓ cup flour

1 teaspoon paprika

¼ teaspoon salt

¼ teaspoon dry mustard

2 cups whole milk

1 teaspoon Worcestershire sauce

¼ teaspoon bottled hot pepper sauce

1 cup shredded processed sharp American cheese (4 ounces)

Place oil in a medium saucepan. Stir together flour, paprika, salt and dry mustard. Add flour mixture to oil; cook and stir for 1 minute. Stir in milk all at once. Cook and stir over medium heat until thickened and bubbly. Cook and stir 1 minute more. Remove from heat; stir in Worcestershire sauce and hot pepper sauce. Add cheese and stir until melted. Makes 2 cups.

Hotel Julien Dubuque Serves First-Class Food, Gangster History

In an era of standardized, nondescript motel and hotel chains, it's easy to forget that there was a time when fine hotels were as diverse—and unique—as the local communities they served. From their exceptional dining options to their distinctive décor, these showplaces reflected the culinary traditions that are as much a part of Iowa as its fertile, black soil.

The Hotel Julien Dubuque near the Mississippi River combines a fascinating blend of local history and modern fine dining. Since 1839, a hotel or inn has occupied the corner of Second and Main Street in Dubuque, the present site of Hotel Julien. The original structure, four stories high, was called the Waples House and was the first building visible to travelers entering Dubuque from across the Mississippi River. The Waples House, which was furnished extravagantly, was known far and wide for its gourmet cuisine and hosted famous guests such as Abraham Lincoln, "Buffalo Bill" Cody and Mark Twain.

In 1854, the hotel was enlarged, remodeled and renamed the Hotel Julien after the city's namesake, Julien Dubuque. Shortly before the turn of the

100 Years 1915 - 2015

Thanks to a multimillion-dollar investment in recent years, the Hotel Julien Dubuque near the Mississippi River showcases the classic grandeur of the original 1915 hotel with all the modern amenities, including fine dining at Caroline's Restaurant. *Courtesy of Hotel Julien Dubuque.*

twentieth century, the city of Dubuque rivaled Chicago in size and was fast becoming an important midwestern center for trade and commerce. The Hotel Julien became the focal point of this bustling economy and gained recognition as a gathering place for the city's rich and famous.

Tragedy struck in 1913, however, when the hotel was ravaged by a fire, leaving little in its wake. Construction of the current hotel began at once, and the Hotel Julien Dubuque was again opened for business on September 12, 1915. Since the previous building was destroyed by fire, the new structure of concrete and steel was designed to be fireproof, an attribute that was nearly always noted in newspaper articles and advertisements for the new hotel. Many of the hotel's original fixtures still grace the décor today, including an ornate mailbox near the elevators in the lobby.

While the Hotel Julien Dubuque became known as one of the finest hotels in the Midwest and hosted many grand banquets and famous guests, none has aroused more curiosity and speculation than the notorious Chicago gangster Al Capone. Local lore alleges that when things got "hot" in Chicago in the late 1920s and 1930s, Capone would travel with his

entourage to Dubuque and hide out at the Hotel Julien. He allegedly took over the entire eighth floor, which offered a prime vantage point. Capone's guards watched for the feds or rival gangs crossing the Mississippi River from Illinois. Capone reportedly made use of a nearby underground garage to hide his cars to further conceal his presence in Dubuque. Some say he even owned the hotel at one point.

In 1962, the Julien was purchased by Louis H. Pfohl and, after extensive remodeling, became the Julien Motor Inn with its modern, refined atmosphere. During this remodeling phase, many interesting and historic artifacts were incorporated into the décor, including the stunning stained glass in the Hotel Julien Dubuque's restaurant, which is known today as Caroline's Restaurant.

Caroline (Rhomberg) Fischer was the great-great-grandmother to the three cousins who today manage the Fischer Companies and the Hotel Julien Dubuque. She was a driving force and entrepreneur far ahead of her time. In the days before electric freezers and electric refrigeration, Caroline's husband, Louis, was a partner in the Fischer ice business. After Louis contracted pneumonia and died in 1875 after falling into the Mississippi River while cutting ice, Caroline took over his ice business. The thirty-one-year-old widow with five young children was a hard worker. Caroline is said to have followed her ice deliverymen around town in her own horse-drawn buggy to be sure that her men were doing their work properly. The many taverns to which they delivered would offer drinks to the drivers in an effort to persuade them to leave a little extra ice. On occasion, upon finding the drivers passed out in the ice wagon, Caroline would drive their team of horses and wagon back to the ice storage warehouse herself with her own horse and buggy in tow.

In 1878, long before the Fischer Company owned the Hotel Julien, the Fischer Wheeler & Company ice business had a contract with the Hotel Julien Dubuque to supply ice to the guesthouse, then under management of W.W. Woodworth. The three-year contract was for "all the ice necessary" for $25 a month or $300 for the entire year.

Caroline eventually bought out her partners, invested in downtown and riverfront property and brought her family into the business that still exists today. Located in view of the Ice Harbor, where the Fischer family business started, Caroline's Restaurant at the Hotel Julien Dubuque is a tribute to the Fischer/Pfohl family matriarch.

The many fine dining options available at Caroline's Restaurant at the Hotel Julien Dubuque (including the fabulous Caroline's Banana

Bread French Toast, served with caramelized bananas) reflect the rebirth of the hotel, which was inspired by the renaissance of downtown Dubuque, especially the Old Main District in which the Hotel Julien Dubuque is located.

While traditional Iowa fare tends to be meat and potatoes, Executive Chef Jason Culbertson at the Hotel Julien Dubuque noted that a food revolution is underway. "Our culinary roots are heavily influenced by cuisine that our ancestors brought from Canada and European countries," said Chef Culbertson, a Dubuque native and graduate of Le Cordon Bleu College of Culinary Arts in Minneapolis. "Iowans certainly produce quality meat, but we're definitely doing meat and potatoes in a more sophisticated, contemporary way."

The menus at Caroline's Restaurant are influenced by what's grown locally and what's readily available. "We're also emphasizing plating and presentation more than ever, with a focus on making our dishes as aesthetically pleasing as they are delicious," Chef Culbertson added.

In late 2007, the descendants of Louis Pfohl began an extensive renovation of the historic Dubuque hotel. The Hotel Julien Dubuque hosted its grand reopening in September 2009. Thanks to a $33 million investment, the Hotel Julien showcases the classic grandeur of the original 1915 hotel with all the modern amenities. Guests from all over the world have experienced this remarkable boutique hotel, a landmark of luxury, sophistication and history.

Paying homage to the notorious midwestern gangster of the Prohibition era, the Capone Suite is tucked away in a private area of the hotel and offers a vintage theme that's rich with old Hollywood glamour. With its grand entrance, two bedrooms, king-sized beds, luxury linens and a relaxing whirlpool tub separate from the private bathroom, the suite feels like an exclusive retreat within the Hotel Julien Dubuque. French doors open to the grand living area and fully equipped kitchen with full-sized appliances. With panoramic views of the mighty Mississippi, this private, spacious suite provides ample room to entertain and returns guests to an era of living large while offering a taste of the good life, much like the Hotel Julien Dubuque itself.

Chapter 7

FAIRS, TRADITIONS AND CELEBRATIONS

While Iowans work hard, they also like to celebrate. Iowa showcases unforgettable food at its county fairs (including Clay County's "World's Greatest County Fair," a Spencer tradition since 1918) and the legendary Iowa State Fair.

The internationally acclaimed Iowa State Fair in Des Moines is the single largest event Iowa. As one of the oldest and largest agricultural and industrial expositions in the country, the Iowa State Fair annually attracts more than 1 million people from all over the world each August. The Iowa State Fair is also the only fair listed in the *New York Times'* best-selling travel book, *1,000 Places to See Before You Die*. Domestic diva Martha Stewart even spent a day at the fair in 1999 to record segments for her hit television show.

The first Iowa State Fair was held in the southeast Iowa town of Fairfield October 25–27, 1854. The fair moved to its permanent home on the east side of Des Moines in 1886 on a park-like, 450-acre setting. From the beginning, the heart of the Iowa State Fair has been food—the making and eating of it.

The Iowa State Fair and food-on-a-stick are synonymous. About seventy foods are available on a stick, including pickles, corn dogs, corn on the cob, deep-fried candy bars, hard-boiled eggs, salad (yes, salad!) and more. With its famous Pork Chop on a Stick, the Pork Tent at the Iowa State Fair has become the quintessential photo op for presidential hopefuls trying to drum up support before the Iowa Caucus.

The Iowa State Fair also features the largest food department of any state fair in the nation, with nearly nine hundred classes. Arlette Hollister

The internationally acclaimed Iowa State Fair (shown here in the 1940s) in Des Moines is the single largest event Iowa. As one of the oldest and largest agricultural and industrial expositions in the country, the Iowa State Fair annually attracts more than 1 million people from all over the world each August. *Courtesy of the Iowa State Fair.*

has presided over the food department for thirty years, overseeing contests that have ranged from cinnamon rolls to ugly cakes to "make it with lard." In 2014, the fair's food contests attracted ten thousand entrants. Part of Arlette's vision for an orderly department is to properly honor all the hard work of Iowa cooks who've made their pilgrimage to Des Moines, gingerly cradling their creations, all for the chance to win thousands of dollars (in the cinnamon roll contest), a blue ribbon or simply bragging rights.

For some, entering the Iowa State Fair's food competitions is a family affair. Among them, the Tarbell family of Centerville is without equal. For generations, they have won an estimated ten thousand ribbons in food contests. The family includes matriarch Olive Jean Tarbell, daughter Robin Tarbell-Thomas and granddaughter Molly Thomas, who have competed in contests ranging from canned goods to cookies.

Want to re-create a taste of the Iowa State Fair? A selection of winning recipes from the fair's food contests is collected in the Iowa State Fair cookbook, which was first printed in 1983. A new cookbook is published every other year. To date, eighteen editions have been printed.

The famous Butter Cow has been a big draw at the Iowa State Fair for decades. The art of butter sculpture at the fair dates back to 1911. It takes an estimated six hundred pounds of butter and sixteen hours to craft the Butter Cow. Norma "Duffy" Lyon served as the fair's famed "Butter Cow Lady" for more than forty-five years. *Courtesy of the Iowa State Fair.*

Not interested in competition cooking? No problem. The Iowa State Fair offers something for everyone, including the famous Butter Cow. The art of butter sculpture has been part of the Iowa State Fair since 1911. It takes an estimated six hundred pounds of butter and sixteen hours to craft the Butter Cow. While Norma "Duffy" Lyon served as the fair's famed "Butter Cow Lady" for more than forty-five years, she spent fifteen years mentoring the current sculptor, Sarah Pratt, who took over the job in 2006. (A bit of trivia—the butter is frozen and stored during the year and reused for three or four fairs.)

Tailgating, Farmer Style

The celebrations don't stop once the state fair is over. When football season rolls around, fans of teams from the University of Iowa Hawkeyes to the Iowa State University Cyclones get fired up for tailgating. That includes farmers like Larry Sailer. Even though Larry is busy harvesting corn and soybeans on his Franklin County farm in the fall, he made time to head to the football stadium in Ames a few years ago when his grandson Devin Lemke played defensive end for the Cyclones.

For a pork producer like Larry, the main course at any tailgate feast naturally features pork, whether it's a smoked loin or grilled pork chops with Larry's famous marinade. He is known for preparing plenty of food to serve at each tailgate, and his wife, Janice, fixes the side dishes, from chip dips to salads. Friends and family stop by to join in the fun.

Larry is also an "agvocate" who helps share the farmer's perspective of modern agriculture. He's the voice behind the popular "Musings of a Pig Farmer" posts that appear weekly in Latham Hi-Tech Seeds' "The Field Position"® blog. "Anything you can do to start a conversation with consumers about food and agriculture is good," said Larry, who has hosted a Japanese film crew at his farm to help spread the message even farther.

With more than 2,400 Facebook friends, Larry taps into a powerful platform to share the story of Iowa agriculture with farmers, ranchers and non-farm friends across the globe. "I use social media as a way to communicate and share ideas in a 'virtual coffee shop.' I never run out of farm and food-related topics to discuss, and it's a great way to connect with people."

LARRY'S PORK CHOPS

A simple marinade adds extra flavor to this easy pork chop recipe.

½ cup soy sauce
¼ of a chopped onion
2 tablespoons sugar
1 teaspoon ground ginger
2 teaspoons vinegar
1 teaspoon garlic powder
6 America's Cut or regular-cut pork chops

Combine all ingredients except the pork chops. Mix well and pour over meat. Marinate pork chops for at least two hours in the refrigerator. Grill or broil pork chops for 8 to 10 minutes on each side.

REMEMBERING SEPTEMBER 11: COMMUNITY'S POTLUCK HONORS AMERICA

While Iowans love to celebrate with great food, some gatherings are much more than a party. Consider the September 11 potluck that Neal and Ginger Tribby host at their home in St. Marys each year to remember the day America changed forever. "It's about appreciating our life, our freedom and all the blessings we have in America," says Ginger, who has hosted up to 200 guests for the annual September 11 remembrance gathering—an impressive number for a community with about 127 people. Since 2002, the annual event has offered a meaningful way to bring the community together, said Dorothy Gavin of St. Marys, who prepares a variety of dishes for the potluck. "We come together to honor those who perished, as well as the firefighters and first responders."

The event has grown each year and includes people of all ages, from children to grandparents. Following an evening potluck meal featuring smoked pork loin, ham balls, cheesy potatoes, salads, cakes, bars, apple crisp and more, guests gather in the Tribbys' backyard near the American flag to sing "America the Beautiful" and listen to a patriotic poem. "If that ceremony doesn't make you tear up, nothing will," said

Steve Lininger, who had traveled 150 miles from Rock Port, Missouri, to attend the annual gathering when I stopped by in 2014. "September 11 changed the lives of everyone here. The remembrance gathering leaves a lasting impression on you."

Ham Balls

This family favorite comes from Ginger Tribby's mother, Ellen Dooley. Ginger and her sisters often make a triple batch for the September 11 remembrance gathering.

1 pound ground ham
½ pound lean ground beef
½ pound lean ground pork
⅔ cup crackers, crushed
2 eggs
½ cup milk
½ cup finely chopped onions
½ teaspoon salt
¼ teaspoon pepper
½ teaspoon liquid smoke

SYRUP:
1 cup brown sugar
3 tablespoons vinegar
1 tablespoon water
1 teaspoon dry mustard

Combine all the ham ball ingredients. Shape into balls about the size of golf balls and place in baking dish. Combine the syrup ingredients and set aside. Bake ham balls at 350 degrees for 30 minutes. Top the ham balls with syrup and bake another 30 minutes.

DAIRY GOOD

R emember the marketing slogan "Milk does a body good?" Dairy also does a state like Iowa good, from milk to ice cream to cheese. Des Moines was named the number-one large city in terms of per capita consumption of milk, based on 2005 data from the University of Illinois Extension.

While nearly every small town and city had a creamery in years past, Iowa's dairy industry has evolved. With dairy farms primarily located in the northeast and northwest corners of the state, Iowa remains a leader in America's dairy industry. According to the Iowa State Dairy Association, Iowa ranks:

- twelfth in total pounds of milk produced
- ninth in fluid milk bottling
- eighth in total dairy products processed
- seventh in number of dairy herds and seventh in cheese production
- sixth in cottage cheese production and American cheese production
- fourth in ice cream production

Iowa is also the birthplace of the Eskimo Pie, America's first chocolate-covered ice cream bar. The inspiration for the Eskimo Pie was a boy's indecision when he stopped by Christian Nelson's confectionery store in the western Iowa town of Onawa in 1920. The boy started to buy ice cream and then changed his mind and bought a chocolate bar. Nelson

Iowa is the birthplace of the Eskimo Pie, America's first chocolate-covered ice cream bar. It was created by Christian Nelson in Onawa in the early 1920s. Notice the marketing on the box, which proclaims, "Eat Ice Cream for Health." *Author's collection.*

In years past, many Iowa towns had their own creamery. The Lytton Cooperative Creamery Association was organized in June 1933. Capital for the new venture came from local farmers, who subscribed for shares on a basis of five dollars per cow. In 1936, the creamery produced 110,000 pounds of butter. Grade A milk was processed, bottled and distributed under the name "Lytton Maid" until this was discontinued in 1963. The plant closed in August 1979. *Courtesy of Lytton Museum.*

inquired why he did not buy both. The boy said he wanted them both but only had a nickel.

For weeks after the incident, Nelson worked around the clock experimenting with different methods of sticking melted chocolate to frozen ice cream. Cocoa butter turned out to be the perfect adherent. While Nelson called his creation an "I-Scream-Bar" and patented it, he later teamed up with Omaha confectioner Russell Stover to produce what they began to call the Eskimo Pie. Soon, millions of people across America fell in love with the Eskimo Pie, which is still a favorite treat after all these years.

Wells Enterprises Inc. Scoops the Competition

Ice cream remains big business across Iowa, from the eastern side of the state where Whitey's Ice Cream has been a tradition since 1933 to the northwest Iowa town of LeMars, which claims the title of "Ice Cream Capital of the World." A commitment to innovation defines Le Mars–based Wells Enterprises Inc., maker of Blue Bunny® ice cream, which has offered a taste of the good life for more than a century. As the largest privately held, family-owned ice cream manufacturer in the United States, Wells produces more than 150 million gallons of ice cream per year and distributes products in all fifty states.

"Every day, Wells works hard at bringing joy to everyday life because of the love of ice cream," said Mike Wells, president and CEO for Wells Enterprises.

Founded in 1913 under the original name of Wells' Dairy, Fred H. Wells grew the business as he began manufacturing ice cream around 1925 with his sons. In 1935, the Wells family ran a "Name that Ice Cream" contest in the *Sioux City Journal*. A Sioux City man won the twenty-five-dollar cash prize for submitting the winning entry, "Blue Bunny," after noticing how much his son enjoyed the blue bunnies in a department store's window display at Easter.

By 2014, Wells had manufactured more than 1,100 different ice cream and frozen novelty products. Its signature brand, Blue Bunny, has been one of the fastest-growing brands of ice cream in recent years, said Wells, who added that the company sources dairy ingredients from local farmers and milk suppliers. "Some companies have moved to selling 'frozen dairy dessert' in the ice cream aisle," noted Wells, who is the third generation of his family

In 1935, Wells Enterprises Inc. in Le Mars held a "Name that Ice Cream" contest in the *Sioux City Journal*. John VandenBrink of Sioux City won a twenty-five-dollar prize for submitting "Blue Bunny." He not only submitted the name but also the Blue Bunny® character used for many years on packaging and in the logo. This picture shows a Wells representative presenting the prize money to VandenBrink. *Courtesy of Wells Enterprises Inc.*

to manage the company. "These products contain less of the ingredients required to meet the definition of ice cream, as defined by the U.S. Food and Drug Administration. Blue Bunny gives you *real* ice cream, no substitutes."

ANDERSON ERICKSON DAIRY: RIDICULOUSLY DELICIOUS

A focus on quality you can taste defines the Anderson Erickson (AE) Dairy, which was founded in Des Moines in 1930 and prides itself on "ridiculously delicious" dairy foods. AE remains one of the few family-owned dairies in America.

Today, AE Dairy is managed by third-generation Erickson family members, along with a team of some 475 employees who help make more than three hundred varieties of dairy products. All AE products are produced in Des Moines at the company's one plant. AE often receives "love

letters" from customers who've moved away from Iowa. "They tell us they miss their favorites, which include AE Old Fashioned Cottage Cheese, French Onion Dip, Chocolate Milk and Classic Egg Nog, which is made from a sixty-year-old recipe that offers the flavor of a melted French vanilla milkshake," said Kim Peter, AE's director of marketing.

The freshest, best-tasting dairy products begin with the finest raw milk. "We're fortunate to be able to source our milk from good Iowa family farms, working with some of the best dairy producers in the state," Peter said.

Most AE products are made in small batches, flavor by flavor, with the finest ingredients, including gourmet cocoas and premium fruits. "Everything we do is all about great taste, so we do lots of tasting and testing before we introduce new flavors and products," said Peter, who noted that it sometimes takes months or years to get a flavor just right. "It's one of the reasons we continue the weekly tradition started by our founder, Iver Erickson, of taste-testing products every Thursday."

AE Dairy isn't the biggest dairy, and it doesn't want to be. "We just want to be the best," Peter said. "Dairy is our passion, and we believe the possibilities are endless."

Before the advent of AMBER alerts and social media to help locate missing children, the Anderson Erickson (AE) Dairy in Des Moines led a campaign to place photos of missing children on milk cartons. The first kids to appear on AE milk cartons were twelve-year-old Johnny Gosch of West Des Moines, who disappeared on September 5, 1982, and thirteen-year-old Eugene Martin of Des Moines, who disappeared on August 12, 1984. Both boys were newspaper carriers for the *Des Moines Register* when they went missing on their routes. The Gosch and Martin cases have never been solved. *Courtesy of Anderson Erickson Dairy.*

MAYTAG'S FAMOUS CHEESE
CREATES A RHAPSODY IN BLUE

Iowa's dairy industry boasts one of America's most distinctive cheeses, Maytag Blue Cheese. Maytag Dairy Farms near Newton started making blue cheese in October 1941. Maytag Blue Cheese is unique in many ways, from its small, hand-made batches to its slow aging process. *Author's collection.*

Iowa's dairy industry also boasts one of America's most distinctive cheeses. When the Maytag Dairy Farms near Newton started making blue cheese in October 1941, milk in Iowa was ten cents per quart. While milk prices have changed, the process for making the famous Maytag Blue Cheese has not, and customers from local home cooks to celebrity chef Emeril Lagasse couldn't be happier.

When I visited a number of years ago with Myrna Ver Ploeg, president of Maytag Dairy Farms, I remember her telling me about a letter from Julia Child in the Maytag archives that praises Maytag Blue Cheese. In recent years, demand for blue-veined cheese has been rising, due to a growing trend for more exciting, bolder flavors of cheeses.

Maytag Blue Cheese is unique in many ways, from its small, handmade batches to its slow aging process. When I visited Myrna at the farm, she noted that Maytag Blue Cheese is aged an average of twice the amount of time of ordinary blue, which gives the product its creamy texture and pungent flavor.

The piquant cheese has also grown in popularity with home cooks. Traditionally, blue cheese was found in salad dressing and as an accompaniment to spicy chicken wings, but Americans have discovered that blue's creamy, robust flavor enhances everything from pizza to omelets to burgers. Call Maytag Blue Cheese in all its culinary splendor a gift from the heartland.

BOOTLEGGING, BEER
AND OTHER BEVERAGES

While Iowa is known for unique culinary traditions, it also has an intriguing history when it comes to beverages. Some of the most colorful stories revolve around Iowa's beer and liquor history. Consider the Iowa City Beer Riots of 1884. The trouble started in 1882 when the Iowa legislature voted to prohibit all alcohol, but things got really heated when the new prohibition laws went into effect on July 4, 1884. Iowa brewers were abruptly left with hundreds of thousands of gallons of beer and liquor that were illegal to sell.

It was a big blow to Iowa City's three big breweries (known as the "German Beer Mafia"), whose money and influence ruled much of the local economy. When the beer riots erupted, lynch mobs ranted, women and children were threatened, city lawyers were tarred and drunken mobs reigned in the streets. The riot captured national attention. When national Prohibition eventually settled the alcohol issue, some breweries (in Iowa City and across Iowa) went out of business, while others operated as soda bottling plants. (On a side note, beneath all three former breweries in Iowa City lie extensive beer caves, construction marvels that are still present underground.)

In the northwest corner of the state, Sioux City shared some similar experiences. The city became home to many German immigrants and many breweries, starting in the 1860s. While Iowa's prohibition laws took effect in the 1880s, local city council ordinances could trump state law and allow existing breweries and saloons to keep operating. Sioux City leaders sided with the breweries and saloons, which were big business, said Matt

In the early 1900s, pop bottling companies were common in many small Iowa communities, especially after Prohibition took effect. Here is an extremely rare glimpse inside the Rockwell City Bottling Works, which produced soda pop in a variety of flavors. *Courtesy of Mike Strandberg.*

Sioux City was home to many German immigrants and many breweries, starting in the 1860s. While Iowa passed prohibition laws in the 1880s, local city council ordinances could trump state law and allow existing breweries and saloons to keep operating. Sioux City had at least forty to fifty saloons by the 1880s, along with a population of thirty thousand people. *Courtesy of Sioux City Public Museum.*

Anderson, a curator at the Sioux City Public Museum, who noted that Sioux City had at least forty to fifty saloons by the 1880s, along with a population of thirty thousand people.

While cities like Sioux City that were far from the state capital of Des Moines set their own standards for liquor laws, times were changing by 1916, when Iowa established statewide prohibition, four years before the national policy took effect in 1920. With the passage of the Eighteenth Amendment, which outlawed the manufacturing and selling of liquor, came the illegal manufacture and sale of liquor. Notorious activities occurred all over the country, including Iowa. And most of these activities were dangerous.

TEMPLETON SERVES UP THE "GOOD STUFF"

While Prohibition outlawed the manufacture and sale of alcoholic beverages in the United States from 1920 to 1933, enterprising Iowans, including some Carroll County farmers, found a viable way to supplement their income during the 1920s farm depression and Great Depression. According to local lore, Templeton-style bootlegging began to appear in about 1920 with early batches of homemade liquor made from corn. Shortly thereafter, the now-famous rye whiskey, known for its extremely smooth finish, was commonly produced. The product quickly earned the nickname the "Good Stuff" and brought a certain degree of fame to Templeton (population 350).

As the premium brand of the era, Templeton Rye fetched an impressive $5.25 to $5.50 per gallon (about $70.00 by today's standards). Over the course of its storied history, Templeton Rye became gangster Al Capone's whiskey of choice and quickly found its way into his bootlegging empire. Hundreds of kegs per month were supplied to Capone's gang, who filled the demand of speakeasies from Des Moines to Chicago. After Capone was busted, later legends suggest that a few bottles even found their way inside the walls of Alcatraz to the cell of prisoner AZ-85.

All of this would have been very exciting and profitable except for one thing: the federal agents. The revenue men did their best to enforce the law, while the local booze runners did all they could to avoid being caught. After a while, the feds and some hard-to-catch bootleggers knew one another well enough that a mutual respect developed, with the agents often vowing to get the bootleggers "the next time."

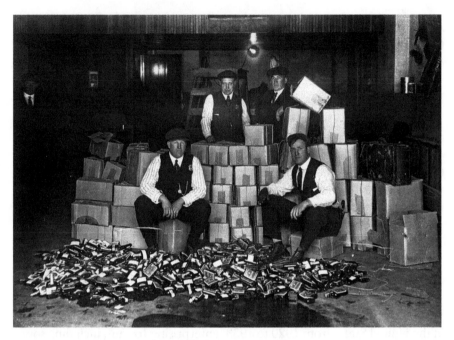

Prohibition outlawed the manufacture and sale of alcoholic beverages in the United States from 1920 to 1933. These Prohibition agents were hard at work in Sioux City. *Courtesy of Sioux City Public Museum.*

The makers of today's Templeton Rye have preserved not only the flavor but also the history of Templeton Rye whiskey as told by the families who were closest to it. "Templeton Rye was the favorite whiskey of my dad, my uncles and people who would gather around," recalled Gus Schroeder, who has been featured in a video clip on the Templeton Rye website. "It was the booze of the era."

Templeton Rye was just part of the community and part of the way of life, according to the locals. In those days, not much conversation went on anywhere about Templeton Rye, however. Certain people in the area could get Templeton Rye for you, but they wouldn't tell you where or how they got it. Sometimes the Good Stuff just arrived in fruit jars. To supply the demand, local farmers would stockpile their homemade liquor in barns or any other hiding place that would work.

While Prohibition ended in 1933, many Iowans wouldn't get a taste of Templeton Rye until the 1990s, as a new version of the classic whiskey became available. Part of its appeal lies in its history as much as its flavor. From tales of Al Capone and Prohibition speakeasies to revenue men, Templeton Rye has long been the stuff of legend.

Iowa Uncorked: Grape, Wine Industries Mature in Iowa

In recent years, there has been much more to Iowa's beverage history than beer and bootlegging. With nearly one hundred wineries across the state in 2016, Iowa is reaping the benefits of its wine and grape industry, which pumps millions of dollars into the economy each year as the industry continues to evolve. "While the total number of wineries has stayed around one hundred in Iowa since 2010, the industry is maturing as one to two wineries close or are sold each year, and one to two new ones open," said Michael White, Iowa State University's (ISU) viticulture specialist. "The bigger change is that wineries continue to spread their footprint as they expand into event centers, distilleries, bed-and-breakfasts, restaurants, wedding venues and more."

White has watched Iowa's wine industry grow from humble beginnings to a significant sector of the state's agriculture industry. In 1999, there were only thirteen wineries in Iowa. As of July 1, 2015, Iowa had ninety-seven wineries and three hundred vineyards covering about 1,200 acres.

With nearly one hundred wineries across the state in 2016, Iowa is reaping the benefits of its wine and grape industry. Many Iowa wineries, including Two Saints Winery near St. Charles, produce award-winning wines. *Author's collection.*

What's old is new again when it comes to wine, which has been made in Iowa for more than 150 years. The first commercial vineyard in Iowa was planted in 1857, according to Iowa State University Extension. In 1893, the Council Bluffs Grape Growers Association was formed with twenty-one member growers and one hundred acres of grapes. Both then and now, growing grapes and making wine in Iowa reflects a long-term commitment, both financially and physically. New vineyard plantings require three to five years before yielding a full crop, with another one to three years of aging for wine to be ready for sale. The development of cold-climate grape hybrids has helped fuel Iowa's wine industry growth.

"I believe Iowa is undiscovered in terms of being recognized as a winemaking state," said Anne Zwink, the winemaker at the family-owned and operated Soldier Creek Winery near Fort Dodge. "We love seeing people's reactions to our wines. Many are surprised to find that our grapes can produce quality dry wines, like those of more well-known regions."

Tourists also like sampling award-winning Iowa wines. "We get to meet so many interesting people," said Christine Carlton, who owns Two Saints Winery near St. Charles, which attracts many out-of-state visitors each year, thanks to its prime location near Interstate 35. "People from out of state are often surprised by how beautiful Iowa is. We're glad our winery can help showcase the great things we have to offer here."

Chapter 10

IOWA CLASSICS

There are some foods so "Iowan" that they hardly need any introduction, like fresh Iowa sweet corn or homegrown tomatoes. Some, like chili and cinnamon rolls, seem to defy explanation to the uninformed. Other foods not normally associated with Iowa nonetheless claim a unique tie to the state. Consider Happy Joe's Pizza, which some credit for creating the first taco pizza in America. Fresh, homemade pizza has also put Iowa on the map with the Iowa-based Casey's General Store convenience store chain, which is now the fifth-largest pizza chain in the nation.

Fresh, homemade pizza has put Iowa on the map with the Iowa-based convenience store chain known as Casey's General Store, which has become the fifth-largest pizza chain in the nation. *Author's collection.*

Other foods, like scotcheroos, aren't exclusive to Iowa, but these bake sale favorites are distinctive enough that they are often associated with the state.

SCOTCHEROOS

1 ½ cups granulated sugar
1 cup light corn syrup
1 ½ cups peanut butter
2 teaspoons vanilla
8 cups crisped rice cereal

TOPPING
1 cup chocolate chips
1 cup butterscotch chips

Combine sugar and corn syrup. Cook until mixture boils. Stir in peanut butter and vanilla. Add cereal and stir until well blended. Press mixture into a buttered, 9- by 13-inch pan. Let cool. Mix the chocolate chips and butterscotch chips together and microwave for 3 minutes. Stir until smooth. Spread over cooled bars.

STERZING'S: QUITE POSSIBLY THE WORLD'S BEST POTATO CHIP

While some treats like scotcheroos aren't exclusively Iowan, others, like Sterzing's potato chips, definitely are. Each time you purchase a bag of Sterzing's potato chips from Burlington, you're tasting a bit of Iowa history.

Craig Smith and his team continue the tradition of producing potato chips the same way that founder Barney Sterzing did in the 1930s. "Our ingredients are simple—potatoes, oil and salt," Smith said. "It's our recipe and manufacturing techniques that make the difference."

Barney Sterzing got into the potato chip business to supplement his primary business of candymaking. He developed a specialized process by which he sliced potatoes and slow-cooked them one batch at a time. This process is still used today to maintain the unique flavor and texture that are the trademarks of Sterzing's chips, which are made fresh daily.

Sterzing's potato chips have become one of southeast Iowa's most recognizable food products. They are shipped across the country and around the world. "Our international shipping began during the Vietnam War, when servicemen requested shipments of the chips they grew up eating," said Smith, who began working for Sterzing's in 1980 while he was still in college. "Ours is a unique story, and we're the only potato chip company left in Iowa."

Robert Jackson, an attorney who became acquainted with Sterzing's chips when he was at the University of Iowa in the 1980s, was delighted to rediscover his favorite potato chips when he returned to the Midwest from his home in California recently. "Sterzing's chips offer a taste of America as it should be," he said.

THE MAGIC OF MAID-RITE

Call it the king of the loose-meat sandwiches. A tried-and-true Iowa classic for ninety years, the Maid-Rite is a sandwich unlike any other. But first, let's clarify what a Maid-Rite is *not*. It's not a sloppy joe. (A Maid-Rite is far superior in taste, in my humble opinion.) It's not a ground-beef concoction with ketchup, mustard and sugar in the mix. (Some of these "hybrid" sandwiches with traits of both a Maid-Rite and a sloppy joe can be found in Iowa, and some are quite tasty, but a true Maid-Rite they are not.) Finally, a Maid-Rite is not something you can leave out if you're going to delve into the culinary history of Iowa.

The story of the Maid-Rite began in 1926, when Fred Angell, a well-known butcher in Muscatine, developed a recipe with just the right combination of fresh ground beef (with a specific grind size and meat/fat ratio) and a distinctive seasoning featuring Fred's unique blend of spices. When a deliveryman tasted Fred's new creation, he exclaimed, "This sandwich is made right!" With that, the Maid-Rite legend was born. "The Maid-Rite recipe has stayed the same from the beginning," said Bradley Burt, president and CEO of the Maid-Rite Corporation, based in West Des Moines. "There's no other sandwich like ours."

What started as a small Maid-Rite restaurant in Muscatine grew into one of America's first quick-service, casual-dining franchise restaurants. Today there are Maid-Rite restaurants in eight midwestern states, including thirty-eight stores in Iowa. While the days of five-cent Maid-Rites and homemade

What started as a small Maid-Rite restaurant in Muscatine grew into one of America's first quick-service, casual-dining franchise restaurants. While the days of five-cent Maid-Rites and homemade root beer are gone, today there are Maid-Rite restaurants in eight midwestern states, including thirty-eight stores in Iowa. *Courtesy of Maid-Rite.*

root beer are gone, Maid-Rite continues to pride itself on hometown hospitality. "Maid-Rite restaurants are still a gathering place in many small towns," Burt said.

Some of these restaurants are as rich in history as the Maid-Rite sandwich itself. Taylor's Maid-Rite in Marshalltown is a third-generation business that has been serving central Iowa for more than eighty years. Cliff Taylor purchased the 1928 franchise for $300. For years, Cliff and his family operated Taylor's Maid-Rite Hamburger Shop, baking pies at home and slicing whole pickles from Marshall Vinegar Works and serving buns from Strand's Bakery.

After Cliff passed away in 1944, his son, Don, continued to run the restaurant. Don built a cooler in the basement of his home to store the hamburger, which was ground daily. In 1958, he built a state-of-the-art Maid-Rite restaurant across the street from the original location, outfitting the new store with all stainless steel equipment and two cash registers.

While various generations of the family have operated the business since then, many things haven't changed. Like all Maid-Rite restaurants, each Maid-Rite at Taylor's is made from 100 percent USDA midwestern fresh ground beef served on a bun, with your choice of ketchup, mustard, onion and pickles. "We have stringent specifications for our fresh-ground beef," Burt said.

Once you've tasted a real Maid-Rite, there's no substitute. Many former Iowans don't consider themselves to be officially back home in Iowa until they've eaten a Maid-Rite. "It's quite a phenomenon," Burt said. Some Iowans can't wait to get a taste of home. A group of snowbirds who spend their winters in Arizona host a Maid-Rite party in the Phoenix area each year for 150 guests, complete with Maid-Rite hats, T-shirts and aprons.

One of the biggest Maid-Rite fans of all would have to be Jim Zabel, who broadcast University of Iowa athletic events for fifty years. Before his passing in 2013, the legendary sportscaster and ultimate Iowa ambassador served as the Maid-Rite spokesman. He even made a commercial for Maid-Rite, complete with a riff on his high-energy slogan, "I love 'em, I love 'em, I love 'em!"

Many Iowans stay loyal to their beloved Maid-Rites right to the end. Some people request them as their final meal, while others ask that Maid-Rites be served at their funeral dinner. "Maid-Rite is truly part of Iowa's rich culinary culture," Burt said.

A MOVEABLE FEAST:
RAGBRAI RIDERS ENJOY A TASTE OF IOWA

Pedaling nearly five hundred miles across Iowa on a bicycle in the heat of July should be the recipe for weight loss, but it's hard to resist all the homemade pie and other treats that enthusiasts of RAGBRAI (Register's Annual Great Bicycle Ride Across Iowa) have come to love. "If you go away hungry from RAGBRAI, it's your own fault," said Holly Johnson from Sedona, Arizona, who rode on RAGBRAI in 2012. "RAGBRAI is quite a phenomenon, and we've had excellent food along the way."

Don Hess from Redding, California, was especially pleased with the homemade peach turnover he bought in Lake City during RAGBRAI 2012. "It's excellent," said Hess, a two-time RAGBRAI veteran who enjoys the camaraderie that abounds along the route.

Volunteers who raised money for the Lake City Pool Project made 868 peach, apple and blueberry turnovers, using a recipe that Jane Johnson of Yetter and her daughter, Ali Batz, showcased when they ran Appleberry Farms in Lake City.

Turnovers weren't the only option for pie after the 2012 RAGBRAI riders left their overnight stop in Lake View and headed east on Iowa Highway 175. Members and friends of St. Mary's Catholic Church in Auburn baked nearly 130 pies to serve to the riders.

It takes massive amounts of food to feed the ten thousand registered riders and other people who come along each year on RAGBRAI, a seven-day extravaganza that has become the oldest, largest and longest bicycle touring event in the world since RAGBRAI debuted in 1973. Burning all those calories every day works up quite an appetite for hearty comfort foods like biscuits and gravy. "We sold out of biscuits and gravy at the Union Church by about 8:30 a.m. when RAGBRAI came through Lake City in 2012," said Gerry Weidert, a former Army and U.S. Marine Corps cook. "All our local vendors did well, and we had a lot of fun."

Apple Turnovers

These fruit-filled treats by Jane Johnson and her daughter, Ali Batz, both of Yetter, offer a unique twist on traditional pie.

Pie Dough
2 ¼ cups flour
⅔ cup vegetable oil
⅓ cup hot water
1 teaspoon salt

Apple Mixture
3 to 4 large apples, peeled, cored and sliced
a little cinnamon and sugar (sprinkle on the prepared apples)

Frosting
1 cup powdered sugar
1 teaspoon almond extract
enough water to make frosting

Mix flour, vegetable oil, water and salt together. Roll out dough into small circles and fill each circle with a small amount of apple mixture. Fold dough over the apple mixture in each turnover and seal edges. Bake at 375 degrees for 20 to 25 minutes or until golden brown. Mix all frosting ingredients together and drizzle turnovers with the powdered sugar frosting.

JOLLY TIME INFLUENCES "POP" CULTURE

Much like RAGBRAI, food, family and fun have also created a trifecta of success for Sioux City's JOLLY TIME Pop Corn, which celebrated its 100th anniversary in 2014. "Our greatest joy and constant motivation is bringing families and friends together," said Garry Smith, company president and fourth generation of the Smith family to lead JOLLY TIME Pop Corn.

JOLLY TIME Pop Corn, which celebrated its 100th anniversary in 2014, remains a family-owned business based in Sioux City. This 1962 photo shows the Smith boys, including Bud, Carlton, Garry and Chipper, who are part of the family who still own the company. *Courtesy of JOLLY TIME Pop Corn.*

JOLLY TIME was founded in 1914 in Sioux City, where Cloid Smith and his son, Howard, hand-shelled popcorn in the basement of their home. An entrepreneur at heart, Cloid Smith pioneered the U.S. popcorn industry, starting with sales to small grocers and streetcart popcorn vendors. "Our company's products have carried the Good Housekeeping Seal since 1925, longer than any other food product," Smith noted.

Through the years, JOLLY TIME's product lines have evolved in the ever-changing snack food market. The 1980s, for example, brought the advent of microwave popcorn. The early 2000s led to the creation of new popcorn varieties for more health-conscious snacking. Today, JOLLY TIME offers its American-grown products in grocery stores nationwide and in nearly forty countries. It's still based at its "One Fun Place" street address in Sioux City and remains a family-owned business with 180 employees as of 2014. "We have a great staff, and we have a good time reaching our goal of capturing a bigger piece of the market in many different places," Smith said.

PALMER CANDY COMPANY MAKES LIFE SWEET

Another proud Sioux City tradition, the Palmer Candy Company, has been making life sweeter since 1878. Family-owned and operated for five generations, the Palmer Candy Company produces many chocolates and confections, including the Twin Bing, a midwestern favorite since 1923.

The Palmer Candy Company operates today as not only one of the nation's oldest candy companies but also the oldest company of its size to be under continued family ownership in the United States. While the Palmer Candy Company's treats can be found in convenience stores across the Midwest, don't miss the chance to visit Palmer's Old Tyme Candy Shoppe. Located close to Interstate 29, Palmer's Old Tyme Candy Shoppe houses a small museum with vintage candy-making equipment, historic photos and other fun items.

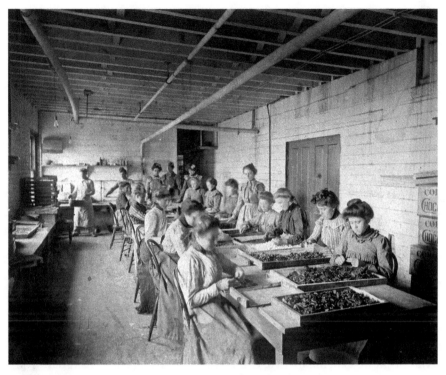

The Palmer Candy Company in Sioux City has been making life sweeter since 1878. Family-owned and operated for five generations, the Palmer Candy Company produces many chocolates and confections, including the Twin Bing, a midwestern favorite since 1923. *Courtesy of Palmer Candy Company.*

Chili and Cinnamon Rolls Remain the Best School Lunch Ever!

What goes with chili? Cinnamon rolls, of course. No one knows exactly where the splendid idea of eating cinnamon rolls with chili began, but it has become an obsession for generations of school kids across Iowa.

There are variations of this classic combination. In the former Lake City School District, for example, the talented school cooks (including many farm wives who were expert home cooks) started early in the morning on chili day to make their fabulous homemade caramel rolls. This feat of culinary perfection is unforgettable for anyone who attended school in Lake City from the 1960s through the early 1990s. The sweet, spicy aroma emanating from the kitchen by midmorning was enough to have every stomach growling. My

classmates and I can still taste the pure bliss bursting forth from each bite of sweet, golden caramel that enveloped soft, twisted folds of dough slathered with creamy butter and cinnamon.

Other schools in Iowa served cinnamon rolls with white frosting rather than caramel rolls on chili day. Still other school districts served peanut butter sandwiches on chili day. While a few unfortunate souls who grew up in Iowa claim they never experienced chili and cinnamon rolls for school lunch, it's a beloved tradition that continues to delight countless young Iowans in school districts across the state.

While the "chili and cinnamon roll" phenomenon seems to be a distinctly Iowa thing, a few other midwestern states lay claim to it as well, including Nebraska and Kansas. Not all midwesterners have been initiated into the joys of chili and cinnamon rolls, however. When I described this magical combination to a friend who grew up in Minnesota, she recoiled in horror and exclaimed, "That combination makes no sense. It's like serving scrambled eggs with birthday cake!"

Before you turn your nose up in disgust at this seemingly odd food pairing, let's take a little side trip to Cincinnati, Ohio, one of the most chili-crazed cities in the United States. In a lot of ways, Iowa's combination is reminiscent of Cincinnati-style chili. Cincinnati chili is quite different from its more familiar Texas cousin and has developed a cult-like popularity. Not only does it have a thinner consistency, but it's also prepared with an unusual blend of spices, including cinnamon.

This brings us back to Iowa. Want to sample authentic Iowa-style chili and cinnamon rolls? It's not just for school lunch anymore. In Sioux Center, Casey's Bakery (not the ubiquitous midwestern convenience store chain but a locally-owned business open since 1946) promotes its "Chili Bash," which is served on Thursdays in the winter months. Guests enjoy all-you-can-eat chili—served with cinnamon rolls, of course, as well as a drink.

Then there's Meal Combo no. 11 at the Runza® chain of fast-food restaurants (with locations in Council Bluffs and Clarinda), featuring Runza's homemade chili with cinnamon rolls. Nebraska-based Runza knows that this might be a bit shocking for the uninitiated. "If you tell someone who's not from the Midwest that you like chili and cinnamon rolls together, they'll look at you like you have three heads," reads the company's online promotion for Meal Combo no. 11. "But if you let them try Runza's® homemade Chili with Miller & Paine® Cinnamon Rolls, they'll still look at you like you have three heads, but they'll also be like, 'Hey guy, you were right, this is fantastic.'"

Perhaps the real issue here is this: can we get away with eating dessert with our meal? Better yet, can we fulfill our fantasies of eating the dessert first? You bet, especially since the chili and cinnamon roll sensation continues in school-lunch programs across the state in both public and private schools. Take Kuemper Catholic Schools in the western Iowa town of Carroll, where homemade chili and cinnamon rolls have remained a staple of hot-lunch offerings through forty years of handwritten recipe books.

In a February 2015 feature story from the *Carroll Daily Times Herald* newspaper, Kuemper food service director Lynne Humphrey said she suspects the unusual meal combination started because the government sent schools tons of flour, beans and tomatoes. The cooks at Kuemper Catholic School system still make homemade cinnamon rolls on a grand scale. Their recipe includes 50 pounds of flour, 4½ cups of yeast, 18 cups of dry milk, 10 cups of sugar, 8½ cups of oil and 11 quarts of water, according to the news article.

The marvelous meal is served about once a month. The article reported that Humphrey's staff made 487 from-scratch, hand-frosted rolls and thirty-five gallons of chili in the high school kitchen recently. While the kids may be picky when it comes to the chili, with some taking the time to extract the beans or tomatoes, they have no trouble eating all the cinnamon rolls. These kids are learning what generations of Iowans already know: the only proper way to eat chili is with cinnamon rolls.

While it seems like everyone has their own recipe for chili, many of the award-winning entries in chili cook-offs across Iowa include a hint of sweetness from brown sugar, grape jelly or other secret ingredients. The best cinnamon rolls, however, tend to revolve around one secret ingredient: mashed potatoes. The potatoes don't change the flavor but help keep the rolls moist.

Just ask Jerry Schleisman of Lake City, a farmer and cinnamon roll baker extraordinaire. He usually makes caramel rolls from his mother's cinnamon roll recipe, just like she used to make on chili-and-cinnamon-roll day at the local high school. Jerry learned from the best. His late mother, Loraine (Schroeder) Schleisman, spent a lifetime refining her culinary skills. She grew up on a farm near Carroll and began cooking at a young age. After she and her husband, Earl, started a family and settled in the Lake City area in the early 1940s, she cooked for their nine children. After Earl passed away, Loraine began cooking at the high school in Lake City and thoroughly enjoyed her job.

She and her fellow cooks would start early in the morning to bake the luscious, gooey caramel rolls that delighted generations of students. Loraine kept cooking long after she retired from the school. She sold homemade baked goods to people in the area and sometimes prepared up to twenty-four dozen rolls per day. "It wasn't uncommon for Mom to get up at 2:00 or 3:00 a.m. to start the next batch of rolls," Jerry told me during a recent visit at his home.

I'm grateful that Jerry is keeping this baking tradition alive. In addition to baking for his family and friends (when he's not busy farming, of course), Jerry prepares many of his mother's best recipes for the God's Harvest Sale, which is held at St. Mary's Catholic Church the first Saturday each December. It's no wonder why the famous Schleisman caramel rolls often bring $250 to $300 per dozen at the auction. Here's the recipe that Jerry and his mother have relied on for years.

Mom's Favorite Cinnamon Rolls

These sweet rolls can be made as frosted cinnamon rolls or caramel rolls. They stay moist longer than other cinnamon rolls.

1 cup cooked, mashed potatoes (made from Yukon Gold potatoes, preferably)
4 cups potato water
6 tablespoons yeast
2½ cups granulated sugar, divided
1½ cups vegetable oil
4 eggs (at room temperature)
2 tablespoons salt
5 pounds all-purpose flour, sifted
3 to 4 cups granulated sugar
cinnamon, to taste
2½ sticks of butter, melted

Preheat oven to 375 degrees. Peel about three small potatoes and cut into cubes. (Jerry Schleisman prefers Yukon Gold because of their flavor and texture.) Put potatoes into a stock pot and cover with enough water to reserve 4 cups of potato water after the potatoes have cooked. Bring to a boil and cook potatoes until they are soft enough to mash. While the potatoes are cooking, sift the flour.

Remove potatoes from heat. Strain the potatoes, reserving 4 cups of potato water. Mash the potatoes. Cool the potato water to approximately 115 degrees Fahrenheit. (Jerry often places four or five ice cubes in the potato water to cool it faster.)

Dissolve yeast in warm potato water. Add 1 cup sugar and stir to combine. When dissolved, add remaining sugar, vegetable oil, eggs, salt and mashed potatoes to the yeast mixture. (Make sure eggs are at room temperature. If they just came out of the refrigerator, crack them into a bowl, whisk them and warm them in the microwave oven for 20 seconds.) Then add flour, about 2 to 3 cups at a time.

Knead the mixture until it forms a soft, smooth dough. (Jerry kneads the dough by hand for about 10 minutes.) Transfer dough to a large, greased bowl. Allow dough to rise for about 1 hour, until it doubles in size. Punch dough down. Let dough rise again until doubled in size.

Combine the sugar and cinnamon. Punch down dough and roll dough into a rectangle. Spread the dough with butter and sprinkle with sugar and cinnamon. Roll dough into a log and cut into slices to form the individual rolls. (As an alternative to rolling the dough into a rectangle, cut a piece of dough, roll to tie into a double knot, dip into butter and roll in cinnamon/sugar mixture. Repeat until all rolls are made.)

Place rolls in greased 9- by 13-inch baking pans. If the rolls will be caramel rolls, prepare the Cinnamon Roll Caramel Topping (see recipe following). Pour caramel topping over the cinnamon rolls. Bake at 375 degrees for approximately 35 minutes.

After rolls have been removed from the oven, place a sheet of waxed paper or parchment paper across the top of the pan. Carefully flip the paper and the rolls onto the countertop. Scrape remaining caramel topping from the pan onto the rolls. Allow rolls to cool. Makes 4 dozen cinnamon rolls.

<div align="center">

CINNAMON ROLL CARAMEL TOPPING

½ cup brown sugar

½ cup granulated sugar

¼ cup vanilla ice cream

½ cup butter

</div>

Mix all ingredients in saucepan. Boil hard for 1 minute. Pour topping over raised cinnamon rolls. Bake at 375 degrees for 35 minutes.

Steak de Burgo: A Des Moines Classic

Other Iowa culinary sensations involve meatier issues. While steaks come in all forms in Iowa, Steak de Burgo is a regional specialty featured at many Des Moines–area restaurants. This traditional, hearty dish—usually made with a beef tenderloin—is topped with butter, Italian herbs and garlic.

The history of Steak de Burgo, which is virtually unheard of outside of central Iowa, goes back decades. A 1964 *Better Homes and Gardens* cookbook titled *Famous Food from Famous Places* listed Steak de Burgo as a specialty of the house at Johnny and Kay's Restaurant in Des Moines. Tom Campiano, son of Johnny and Kay, said his father brought the recipe from New Orleans, where he was stationed during World War II. When Johnny opened Johnny and Kay's in 1946, Steak de Burgo became a popular house specialty, according to information from the Iowa Beef Industry Council.

Campiano added that chefs who worked for his father would often take the recipe with them when they opened places of their own. Hence the proliferation of Steak de Burgo in Des Moines, the theory goes. Another famous Des Moines restaurant, Johnnie's Vets Club, had its own version of the entrée. While Johnny and Kay's and Johnnie's Vets Club are gone, Steak de Burgo can still be found on many Des Moines restaurants' menus, from Tursi's Latin King to Johnny's Italian Steakhouse.

Des Moines's signature dish always begins the same way, with a great quality piece of tenderloin. While it's incredibly tender, it's not the most flavorful. That's where the additional ingredients come in. It's also where the agreement ends on what defines Steak de Burgo. Cooks include everything from garlic butter to oregano to heavy cream to seasoning salt to vermouth, giving the tender, melt-in-your-mouth beef the distinctive Steak de Burgo flair.

When I asked Chef George Formaro about this, the Des Moines native shared a recipe for his version that pays homage to the flavors of the classic Steak de Burgo. This is the garlic butter and herb version, said George, who emphasized that Iowa beef makes a huge difference.

Steak de Burgo

4 8-ounce beef tenderloin steaks
2 tablespoons canola oil

Spice Mix
1½ tablespoons dried basil
1½ tablespoons dried thyme
2 teaspoons oregano

1 tablespoon chopped garlic
1 tablespoon chopped shallots
1 stick butter
salt and pepper, to taste

Mix spice blend. Season tenderloin steaks with salt and pepper. Coat steaks with spice blend. Save the remaining herbs to season vegetables.

Heat sauté pan over medium-high heat. Add canola oil. When oil has heated, add seasoned tenderloin steaks to the pan. Flip the meat over when the bottom side has browned nicely. Continue to cook on other side until desired temperature is reached. (Do yourself a favor and use a meat thermometer. Do not cook over 145 degrees. Aim for 125 degrees for rare, 135 degrees for medium rare and 145 for medium doneness.)

Remove beef from pan and set aside. In the same pan, add garlic, shallots and butter. Shake pan back and forth until butter is melted. Season with salt and pepper to taste. Pour garlic butter sauce over beef tenderloins and serve.

Better Homes and Gardens Test Kitchen Celebrates Good Taste

Des Moines is home not only to Steak de Burgo but also to the famous Better Homes and Gardens Test Kitchen. The magazine's first test kitchen opened in the city in 1928. "Our mission has always stayed the same: to create recipes that are current and set up home cooks to be successful," said Lynn Blanchard, test kitchen director.

That first test kitchen set the stage for the Meredith Corporation (which produces *Better Homes and Gardens*) to release the first *Better Homes and Gardens Cook Book* in 1930. Although *BH&G* has released many updated versions this classic cookbook with the red-checked cover, readers can still find recipes that reach back decades, from macaroni and cheese to meatloaf and mashed potatoes.

In 2016, the Meredith Corporation had six culinary specialists who test four or five recipes per day. They work in ten side-by-side galley kitchens that combine the beauty of marbled white granite and sleek fixtures with the functionality of cross-sink chopping boards and shallow spice cabinets. The Meredith Test Kitchen tests recipes for eight major magazines, including *Better Homes and Gardens*, *Midwest Living* and *Diabetic Living*, as well as special-interest publications. Here's a typical year for the test kitchen:

- more than 4,500 recipes tested
- more than 2,500 food images produced
- $130,000 spent on groceries
- 1,000 cups of flour
- 480 cups of sugar
- 288 dozen eggs
- 240 cups of milk
- 480 pounds butter
- 144 onions
- 800 teaspoons of salt

DELIGHTS OF THE DOWNTOWN FARMERS' MARKET

Just a few blocks away from the Better Homes and Gardens Test Kitchen is the nationally renowned Downtown Farmers' Market. Since it was established in 1976, the Downtown Farmers' Market in Des Moines has become the oldest, continuously operating farmers' market in America.

In 2013 and 2014, the Downtown Farmers' Market was ranked near the top of the best 101 farmers' markets in America by the *Daily Meal*. Covering thirteen city blocks, the market attracts twenty thousand people each Saturday morning, on average, from May through October. The market has become a premier shopping destination for fresh, local food and unique items. More than three hundred local entrepreneurs, including farmers, producers, bakers, artists and other vendors representing fifty-eight counties across Iowa sell at

the market. No two markets are ever alike. "That's the charm of the farmers' market," said Kelly Foss, market director. "There are always new flavors as the seasons change, and there's something for everybody."

Living History Farms and the Iowa Machine Shed

Beyond downtown Des Moines, the west edge of the Des Moines metro is home to Living History Farms and the Iowa Machine Shed Restaurant. For more than forty years, Living History Farms has told the amazing story of how Iowans transformed the fertile midwestern prairies into the most productive farmland in the world. Throughout the five-hundred-acre open-air museum, visitors travel at their own pace through historical time periods spanning three hundred years, from a 1700 Ioway village to an 1850 pioneer farm to an 1875 Iowa town to a 1900 Iowa farm. Living History Farms also hosts historic dinners during the winter, where guests can sample traditional Iowa fare at the 1900 farm or the 1875 Tangen House.

Pope John Paul II visited Living History Farms in Urbandale on October 4, 1979. A letter from Joseph Hays, a farmer from Truro, Iowa, persuaded Pope John Paul II to come to Iowa. This was the first time any pope had toured America. During his Mass at Living History Farms, Pope John Paul II affirmed the midwestern work ethic, acknowledged Iowa's role as breadbasket for the nation and the world and challenged the 350,000 people in the crowd to provide food for millions who have nothing to eat. *Courtesy of Living History Farms.*

Throughout the year, the nearby Iowa Machine Shed restaurant also offers an authentic taste of Iowa farm cooking. In 1978, the first Machine Shed Restaurant opened on the outskirts of Davenport, Iowa. As the business has expanded and evolved, all Machine Shed restaurants remain dedicated to the American farmer. This Iowa Machine Shed recipe for Stuffed Pork Loin offers a taste of this dedication.

Stuffed Pork Loin with Sage Dressing

6 cups dry bread cubes
2 celery stalks, sliced
1 medium onion, chopped
¼ cup butter
1 teaspoon dried sage, crushed
½ teaspoon salt
½ teaspoon poultry seasoning
½ teaspoon ground black pepper
½ cup chicken broth
1 2.5-pound boneless pork top loin roast

Spread bread cubes in a shallow baking pan. Bake in a 350-degree oven for 10 to 12 minutes, or until lightly toasted, stirring once or twice; set aside. In a large skillet, cook celery and onion in butter over medium heat until tender but not brown. Remove from heat. Stir in sage, salt, poultry seasoning and pepper. Place bread cubes in large bowl; add vegetable mixture. Drizzle with enough chicken broth to moisten, tossing lightly to combine. Set stuffing aside.

To stuff pork, cut a lengthwise slit in the pork roast, cutting almost through the roast. Spoon some of the stuffing into the slit; tie roast closed with clean, 100 percent cotton kitchen string.

Place roast in a shallow roasting pan. Spoon any remaining stuffing around the roast. Cover roast and stuffing with foil. Roast for 1 hour. Remove foil. Roast for 35 to 45 minutes more, or until internal temperature of meat registers 155 degrees Fahrenheit. Cover and let stand 15 minutes. Remove string and serve.

IT TAKES AN IOWAN

I owa isn't remarkable just for its culinary traditions. Countless Iowans have also made tremendous contributions to food production and food security around the world. Perhaps the best known is Herbert Hoover, the first president born west of the Mississippi River.

Born in 1874 in a two-room cottage in West Branch, Hoover became a tremendous humanitarian before he served as the thirty-first president from 1929 to 1933. Although accused by some of reacting callously to the millions of Americans forced into bread lines during the Great Depression, Hoover was recognized around the world as such a great humanitarian that he was nominated five times for the Nobel Peace Prize.

In World War I, the U.S. government recruited Hoover to deliver food to Belgium, where 7 million people faced starvation. Hoover later headed the American Relief Administration, which delivered food to tens of millions of people in more than twenty war-torn countries. After World War II, President Harry Truman asked the Republican Hoover to coordinate efforts to avert a global famine. Some historians say that Hoover fed more people and saved more lives than any other man in history.

Born in West Branch, Iowa, Herbert Hoover (right) became a tremendous humanitarian before he became the thirty-first president of the United States in 1929. During World War I, the U.S. government recruited Hoover to deliver food to Belgium, where 7 million people faced starvation. Hoover later headed the American Relief Administration, which delivered food to tens of millions of people in more than twenty war-torn countries. Some historians say that Hoover fed more people and saved more lives than any other man in history. *Courtesy of Herbert Hoover Presidential Library and Museum.*

CITIZEN DIPLOMACY THROUGH CORN: WHEN RUSSIA AND IOWA CAME TOGETHER

At the height of the Cold War, an invitation from an Iowa farmer to the Soviet premier led to a historic meeting in Iowa focused on one key topic: food.

Roswell Garst, a plain-spoken, no-nonsense promoter of hybrid seed corn, urged Soviet premier Nikita Khrushchev to tour his Coon Rapids farm. It's hard to overstate the global impact of Khrushchev's visit on September 23, 1959, a day that transfixed Iowa and the world. The tour showcased agriculture's expanding productivity in post–World War II America, driven by plant breeding and rapid advances in farm equipment technology. Khrushchev's visit to west-central Iowa came about because Garst, a fervent capitalist who believed that hungry people are dangerous

At the height of the Cold War, an invitation from an Iowa farmer to the Soviet premier led to a historic meeting in Iowa focused on one key topic: food. Roswell Garst, a plain-spoken, no-nonsense promoter of hybrid seed corn, urged Soviet premier Nikita Khrushchev (front row left) to tour his Coon Rapids farm. The visit on September 23, 1959, transfixed Iowa and the world. *Courtesy of Ohio History Connection and photographer Joe Munroe.*

people, recognized that the Soviets needed to raise more corn, a belief shared by the Soviet premier.

Although Garst's willingness to trade with America's avowed enemy cost him some friends and customers, Khrushchev's visit to rural Iowa helped to thaw the escalating Cold War. "You can't start a journey without taking the first step, and Roswell Garst was one of the first Americans to take that first step," said Khrushchev's son Sergei Khrushchev, a naturalized American citizen and professor at Brown University who I heard speak in Coon Rapids on August 29, 2009, in honor of his father's historic visit fifty years earlier.

Khrushchev came to power in the Soviet Union in 1955, two years after Joseph Stalin's death. During this period, agriculture in the Soviet Union

suffered greatly from Stalin's emphasis on Soviet military power and industrialization, both of which came at the expense of food production.

Feeding the nation's people remained a challenge for the Soviet Union when Khrushchev suggested that his nation needed an Iowa Corn Belt. The world press picked up the remark and reported it extensively, as it marked the first time a Soviet leader had said anything good about the United States since the Cold War began in 1946. The *Des Moines Register*'s Lauren Soth responded with an editorial urging the Soviet Union to compete in a race to raise the most corn, instead of a race to produce the most bombs. Soth was awarded a Pulitzer Prize for the editorial, and the Kremlin took note.

This paved the way for farm exchanges between the United States and the Soviet Union, including Roswell Garst's first trip to the Soviet Union in 1955, culminating with Khrushchev's acceptance of Garst's invitation to visit Iowa. An army of reporters and cameramen covered Khrushchev's every move when he spent a full day at the Garst farm on his 1959 trip to the Midwest, which also included tours of Iowa State University, the Deere & Company plant in Ankeny and Bookey Packing's meat processing plant in Des Moines. For Garst and Khrushchev, a capitalist and a communist drawn together by food and farming, the event offered a rare opportunity to discuss everything from soils to seeds.

"The two men were really quite alike," said Garst's granddaughter Liz Garst. "They were both big-idea men who were absolutely passionate about agriculture and food production."

While Khrushchev failed to replicate America's ever-increasing agricultural production, his willingness to look to the West for ag technology left a legacy that hasn't been forgotten. "Khrushchev's visit to Iowa had a major impact on feeding the world, and we need partnerships like this today to feed a world that's increasingly food insecure," said Michael Michener, a New London, Iowa native and former administrator of the U.S. Foreign Agricultural Service who spoke at the fiftieth anniversary ceremony in Coon Rapids. "Food security is more than alleviating hunger, because it's inextricably tied to economic security, which is tied to national security."

Corn Casserole

Food for the 1959 Khrushchev luncheon in the Garst family's backyard near Coon Rapids was mostly raised on the farm and then sent to the Des Moines Sky Room at the Des Moines Airport for preparation. "That way they could provide better security during food preparation," said Liz Garst. "They also had American and Soviet food tasters eat the food early to make sure it wasn't poisoned." This classic corn casserole is a recipe that came from Liz's grandmother.

2 quarts corn, fresh or frozen
1 cup diced red pepper
1 cup diced green pepper
2 cups diced onion
½ cup granulated sugar
1 teaspoon salt
pepper, to taste
2 cups half-and-half
4 cups finely crushed cracker crumbs
¾ cup butter, melted

Drain any liquid from the 2 quarts of corn. In a casserole dish, combine corn with red pepper, green pepper, onion, sugar, salt and pepper. Mix well. Add half-and-half and 2 cups cracker crumbs. Mix again. Top with remaining 2 cups cracker crumbs. Pour butter on top of casserole. Bake for 1 hour at 350 degrees Fahrenheit.

Iowa's Homegrown Hero: World Food Prize Honors Norman Borlaug

Had Norman Borlaug become a science teacher as he once planned, this Iowa native might have affected hundreds of students during his career. Instead, he became the genius behind the Green Revolution and is sometimes credited with saving more lives than any person who ever lived.

"Norman Borlaug is a hero," said Kenneth Quinn, president of the Des Moines–based World Food Prize, which recognizes breakthrough achievements in the fight against hunger.

Borlaug's legacy is preserved in the World Food Prize headquarters' Hall of Laureates, which is housed in the renovated downtown Des Moines public

Norman Borlaug, who grew up on a Howard County farm near Cresco, developed a high-yielding, disease-resistant wheat that launched the Green Revolution in the mid-twentieth century and saved hundreds of thousands of people worldwide from starvation. Borlaug was awarded the Nobel Peace Prize in 1970. *Courtesy of World Food Prize.*

library. The World Food Prize has renewed interest in the work of a quiet and self-effacing, yet determined, farm boy who never forgot his rural Iowa roots. "Norman Borlaug led the single-greatest period of food production in human history, and this remarkable building preserves his legacy in an awe-inspiring way," Quinn added.

Born in 1914, Borlaug grew up on a Howard County farm near Cresco and was educated in a one-room country school. In 1944, after earning advanced academic degrees, Borlaug accepted an appointment as geneticist and plant pathologist with the new Cooperative Wheat Research and Production Program in Mexico. In his quest to improve wheat yields in some of the poorest parts of Mexico, Borlaug first tried conventional plant breeding techniques but faced many challenges, Quinn said. "He would come close to success, but there was always something wrong. The wheat needed better disease resistance, or sometimes the plants were so lush with grain that they would fall over."

The "Eureka" moment came when Borlaug began working with Norin 10, a semi-dwarf wheat cultivar developed in Japan after World War II. Its thicker, sturdier stalks prevented lodging, and Norin 10 also allowed Borlaug to develop a high-yielding, disease-resistant wheat.

In just a few short years, Borlaug's highly adaptable wheat allowed Mexico to move from being heavily dependent on wheat imports to being a wheat exporter. It also benefited people around the globe, averting a famine that many thought was inevitable in India and Pakistan as the countries' populations boomed during the 1960s and 1970s.

This Green Revolution earned Borlaug the Nobel Peace Prize in 1970. Borlaug continued to work well into his nineties on behalf of the world's starving people. By the time Borlaug passed away at age ninety-five in 2009, he had forever changed the course of history and played a pivotal role with the World Food Prize, which he wanted the world to view as the Nobel Prize for Agriculture. "It's so important to carry on Norman's legacy," Quinn said. "The World Food Prize continues to inspire great the achievements that are needed to feed a hungry world."

THE FUTURE OF IOWA FOOD

W hile Iowa boasts a rich culinary history, this heritage continues to evolve as a wide range of influences refine, and redefine, Iowa food. Just ask my friend George Formaro, a well-known chef and restaurateur from Des Moines. When I asked him for his thoughts on Iowa's culinary heritage and future, here's what he said:

> *I love that there are still places in Iowa that hold on to their heritage. Through the years, many Iowans have come here from somewhere else and figured out how to make it in America. Their stories often involve food. Many of the families of Italian immigrants started in the coal mines, for example, but now their descendants run restaurants. The Greeks had steakhouses and coneys. Asians came to Iowa and opened restaurants, from the early twentieth-century chop suey houses to the modern-day Thai noodle shops and Vietnamese pho places. Mexicans, Central Americans and many others continue to come here and influence Iowa with their food. We're lucky that Iowans have always found a way to survive through food.*

In the past few years, beginning farmers who also are recent U.S. immigrants and/or refugees have come to Iowa from places as diverse as Africa to Asia. Since they face a steeper learning curve due to language and cultural challenges, organizations like the Iowa-based Leopold Center for Sustainable Agriculture have supported training

and marketing education programs for these new farmers, while making accommodations for the unique challenges they face in establishing their operations.

Other influences shaping the future of Iowa food are coming from longtime Iowans, including the Meskwaki. In 2011, the Sac and Fox Tribe of the Mississippi in Iowa (Meskwaki nation) hired a local foods coordinator, along with an economic development director, to create a strategic plan to increase food sovereignty and healthy eating on the Meskwaki Settlement and in the Tama community. In 2013, Red Earth Gardens put seeds in the ground. By its second season of production, the four-acre farm was growing a diverse mix of produce, including strawberries, tomatoes, potatoes, squash, pumpkins, melons, spinach, chard, lettuce, rutabagas, three kinds of kale, radishes, carrots, sunflowers and more. Project leaders were also experimenting with cover crops, mostly a mix of oats, sorghum Sudan grass and rye, to protect soil health.

Similar trends are also taking hold in other parts of Iowa. Near Decorah, the nonprofit Pepperfield Project is promoting the health and development of body, mind and spirit through food and gardening in harmony with nature. Pepperfield Farm serves as a living example of wellness, including an environmentally sensitive lifestyle and its symbiotic relationship with the surrounding community and natural ecosystems. The farm serves as an education and retreat center focused on wellness and the teaching of intelligent choices that support sustainable systems.

Teaching and learning opportunities focused on food also abound throughout Iowa, from the Des Moines Social Club, which offers cooking classes and more, to independently owned culinary specialty stores across the state in Ames, Des Moines, Cedar Falls and beyond.

Other organizations are also helping Iowans make more meaningful connections between food and those who produce it. The Ankeny-based Iowa Food and Family Project, for example, is a group of farmers, farm groups, nutritionists, retailers, food processors, food manufacturers and consumers that was formed in 2011 to help answer people's questions about farming and food production. The Iowa Food and Family Project hosts seminars, food tours and more to showcase how farming and food can unite people and power the quality of life in Iowa.

Just as it has for years, this quality of life will continue to be influenced by foods that evoke a taste of place, transporting you to Iowa's rolling green countryside, fertile fields, scenic rivers, friendly small towns and modern metro areas. These place-based foods offer a unique taste related to the soil,

water, climate and culture of Iowa, as well the ethnic and regional heritage of those who create this delectable food.

I hope you seek out Iowa-inspired foods, whether you're cooking for your family, eating locally when you visit the Midwest or seeking unique gifts from America's Heartland. The foods that comprise Iowa's culinary history and offer a taste of the future not only nourish our bodies but also refresh our spirits.

INDEX

ABOUT THE AUTHOR

 arcy Doughtery Maulsby is a writer, independent marketing specialist and the author of *Calhoun County* with Arcadia Publishing. Described as an "artist with words," this Iowa native has covered agriculture and business for regional and national publications and corporations for nearly twenty years. Maulsby grew up on a Century Farm between Lake City and Yetter. She earned her undergraduate degrees in journalism/mass communication and history from Iowa State University (ISU) in 1996. She completed her master's degree in business administration and marketing at ISU in 2004.

Maulsby is a 2010 graduate of the Iowa Corn Growers Association's I-LEAD leadership class, which traveled to South Korea and Vietnam in the spring of 2010 to assess market potential and market barriers for Iowa ag exports, including corn, soybeans, pork and beef. She is also a graduate of the Iowa Soybean Association's Ag-Urban Initiative leadership class.

When Maulsby is not busy writing and blogging, she enjoys cooking, photography and helping out on her family's corn and soybean farm. In addition, she serves on the board of a number of local organizations, including the Calhoun County Farm Bureau, the Calhoun County Corn Growers and Historic Central School Preservation in Lake City. She is also an Iowa State University Master Gardener, Master Conservationist, Master Tree Steward and certified Kansas City Barbecue Society judge. To learn more, visit www.darcymaulsby.com.